GRAND TETON
a photographic journey

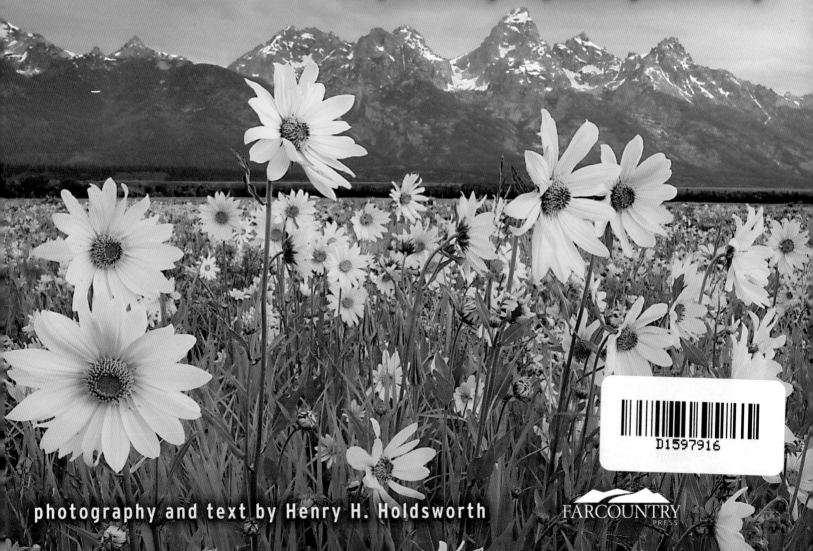

photography and text by Henry H. Holdsworth

FARCOUNTRY
PRESS

D1597916

Right: Grizzly bear 610 surveys the scene at Antelope Flats on a snowy December day. Bear 610 is the daughter of famed grizzly bear 399, and now the second most famous bear in Jackson Hole. I have been photographing her since she was a cub in 2004, and I am always amazed at how many areas of the valley she visits in search of food. She has had at least three sets of her own cubs. Soon after this image was taken, she headed toward her den to hibernate for the winter.

Far right: Fresh snow and alpenglow highlight the high peaks of the Grand Tetons, while the ancient Patriarch Tree stands as a sentinel in the foreground.

Title page: One-flowered sunflowers and sticky geraniums stretch towards the morning sun in the sage meadows of Antelope Flats.

Front cover: Daybreak brings colorful clouds and a perfect reflection to Schwabacher's Landing, a calm side channel along the Snake River.

Back cover: A wrangler heads towards pasture to help bring in the horses during the morning roundup at the Triangle X Ranch.

ISBN: 978-1-56037-674-3

© 2017 by Farcountry Press

Photography © 2017 by Henry H. Holdsworth.
Text by Henry H. Holdsworth.

For more information about our books, write Farcountry Press, P.O. Box 5630, Helena, MT 59604; call (800) 821-3874; or visit www.farcountrypress.com.

Produced in the United States of America.
Printed in China.

21 20 19 18 17 1 2 3 4 5 6

*This book is dedicated to
Travis West and Roberta Mathieu,
my wonderful staff at Wild By Nature Gallery.
I can't thank them enough for always
"making work their favorite."*

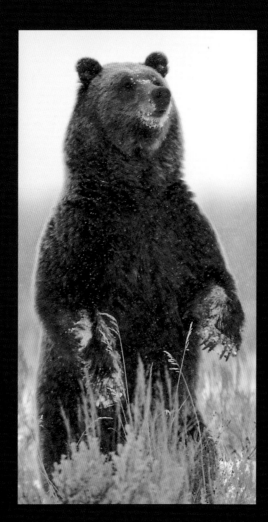

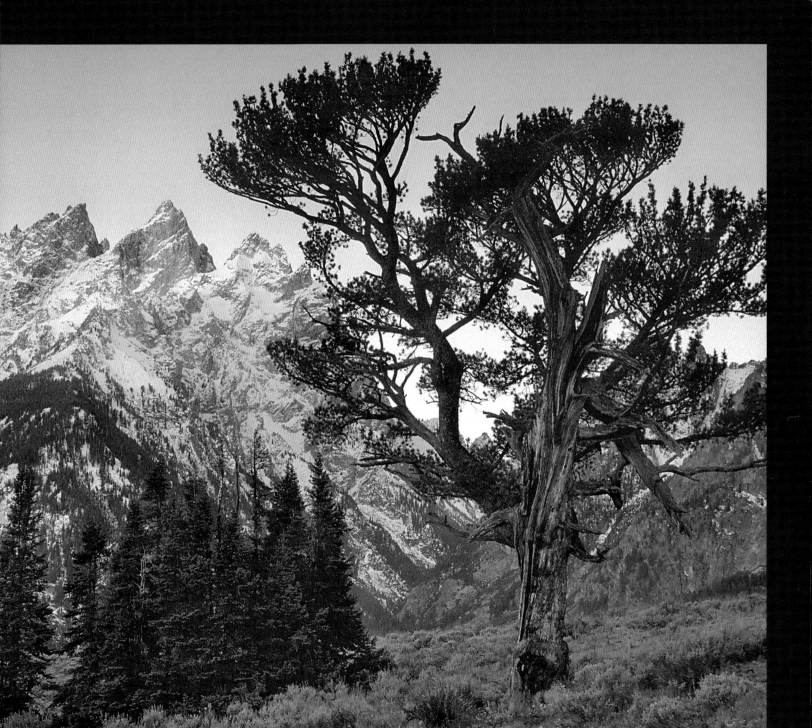

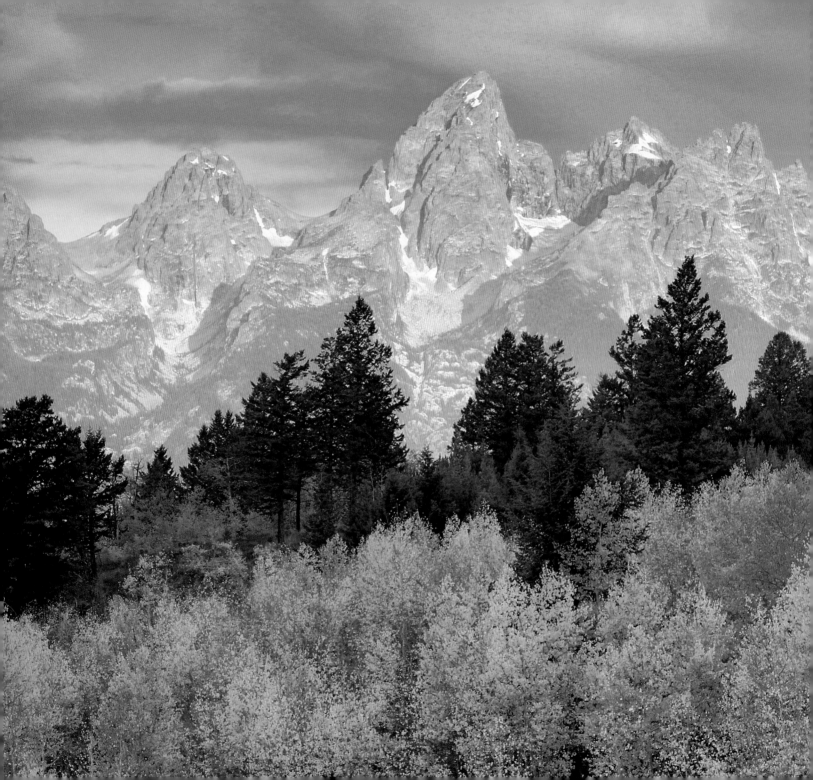

Left: The brilliant colors of a male western tanager stand out like a beacon among the pines.

Far left: Aspen trees and evergreens warm the foreground below the high peaks and glaciers of the Teton Range.

Below: A lone cyclist powers past an aspen grove in full fall color near Oxbow Bend.

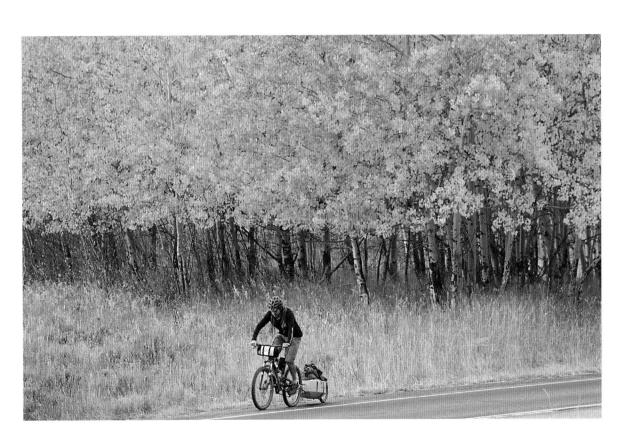

Next pages: A field of lupine and desert parsley waits for the morning sun below the Teton Range near Pilgrim Creek. The golden-colored desert parsley, also known as biscuit root, is a favorite food for bears in late May and early June.

Right: On the National Elk Refuge, a coyote pounces in the hopes of having a vole for breakfast.

Far right: A late spring storm blankets the sagebrush and barns of Mormon Row in the middle of June. With a valley floor elevation averaging over 6,400 feet, it can snow any month of the year in the Tetons. I remember vividly the year it snowed on the 4th of July.

Below: A family of river otters takes a bath in the snow at Oxbow Bend. I have spent three years watching the antics of this family, and I am always impressed at how much fun they typically seem to be having. If I had to come back in another life as an animal, I would want it to be as a river otter.

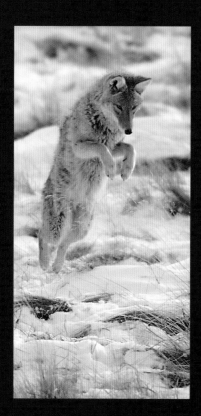

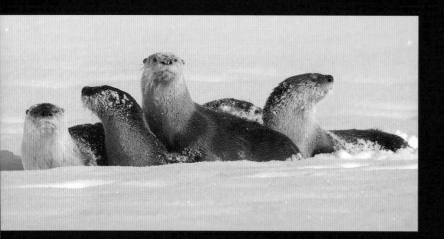

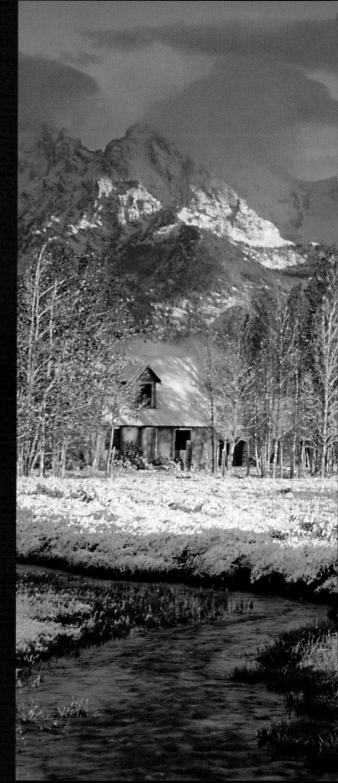

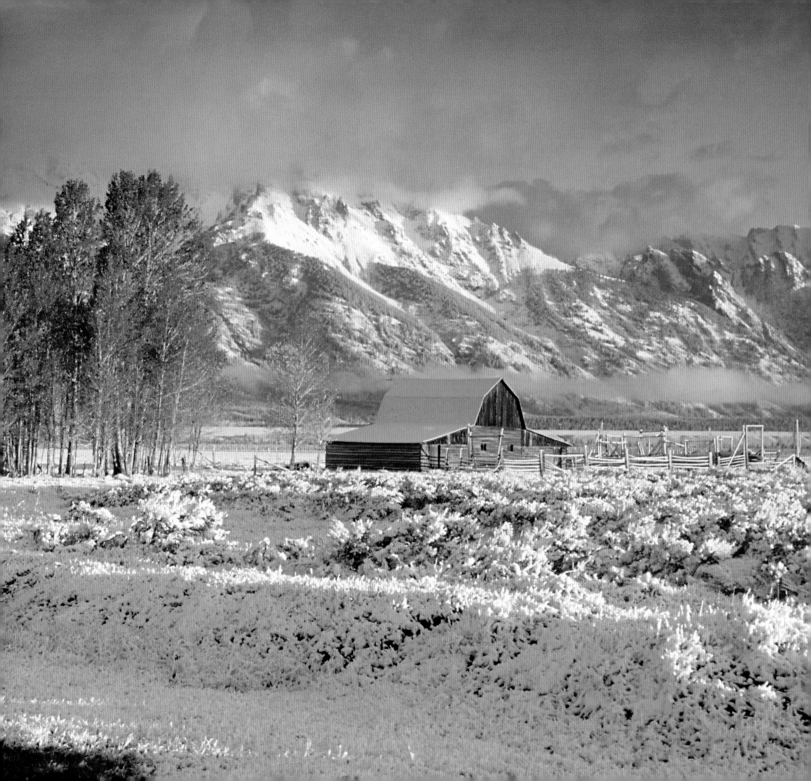

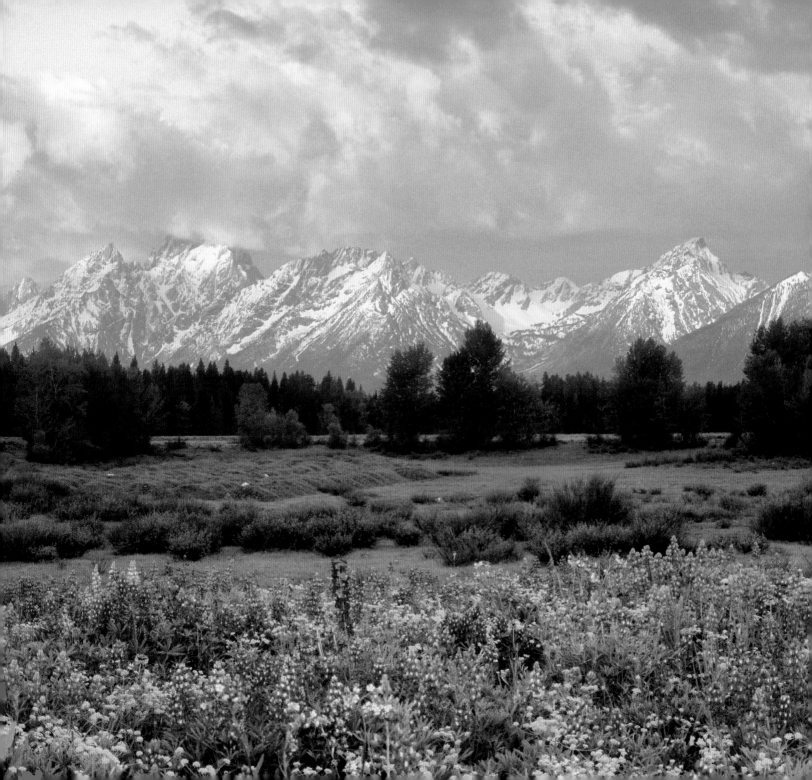

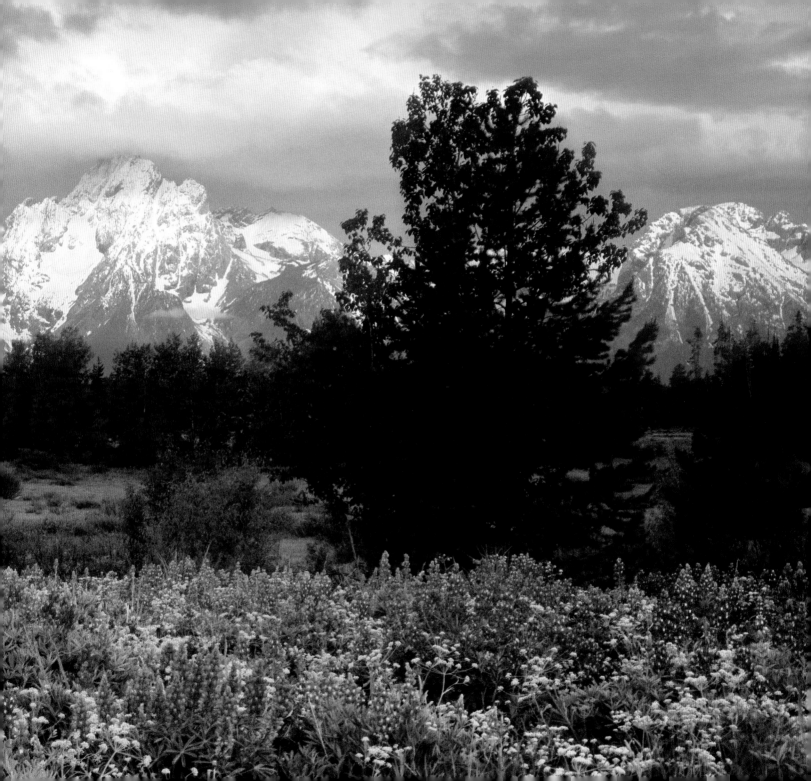

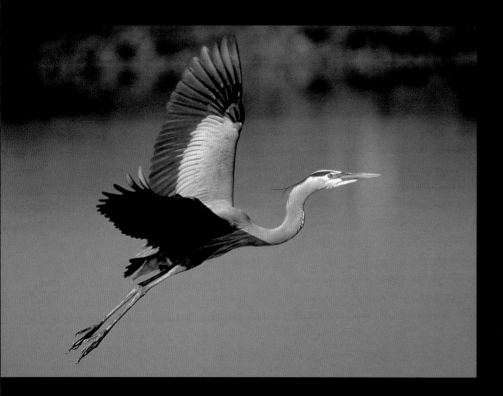

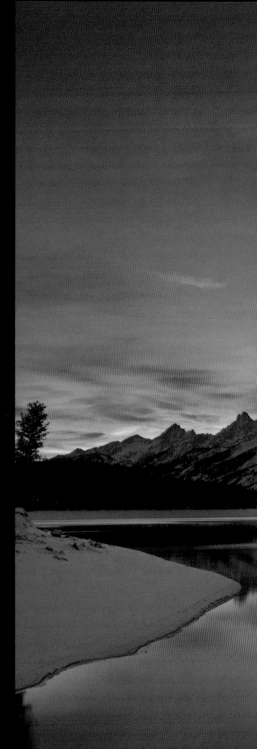

Above: A great blue heron takes to the air. Herons come to the Tetons each summer to nest in rookeries along the Snake River. They can be seen along many of the park's waterways, especially at Oxbow Bend, Schwabacher's Landing, and the ponds on the Moose-Wilson Road.

Right: A glacier lily blooms in one of the upper canyons of the Teton Range. One of the first arrivals after snowmelt, it also goes by the name dogtooth violet.

Far right: The warm hues of sunset surround the Tetons and Jackson Lake. This photograph was taken in December just prior to the lake freezing over for the winter. In a typical year, spring breakup will occur sometime in May.

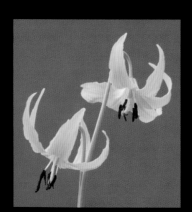

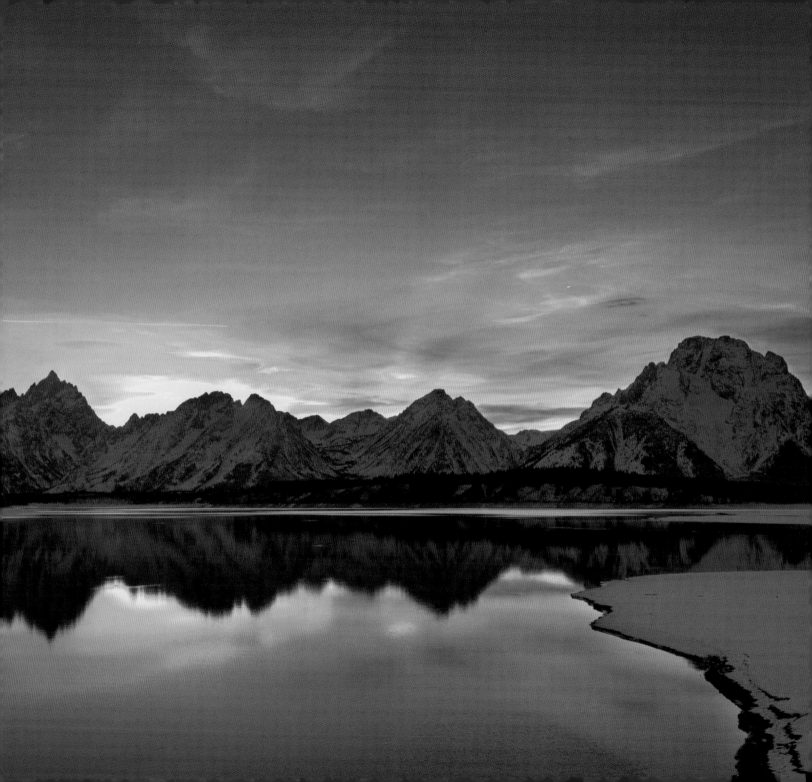

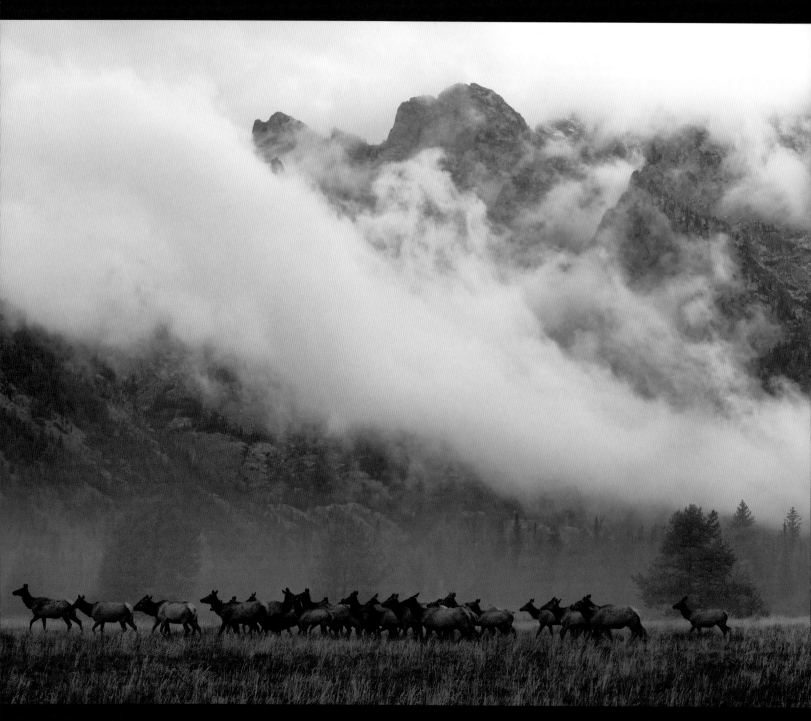

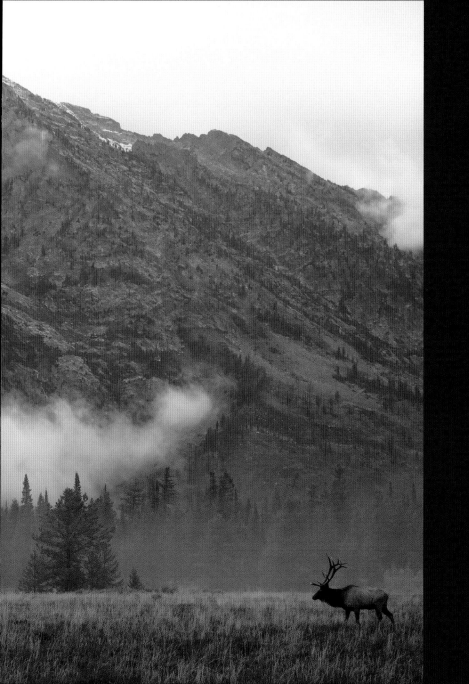

Left: A trophy bull elk escorts his large harem of cows and calves below Mount St. John on a foggy fall morning.

Below: The same bull, photographed the previous year, bugles a wild reveille to his rivals on a cold October day. Jackson Hole hosts the largest elk herd in North America, and to witness the fall rut is truly a feast for both the eyes and the ears.

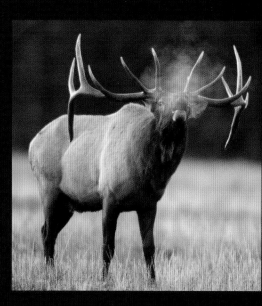

Right: A northern flicker rests outside its nest in an aspen tree near Granite Canyon.

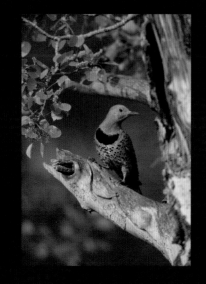

Far right: The porch at Jenny Lake Lodge is a wonderful place to relax and take in the view. Originally a dude ranch, Jenny Lake Lodge is now a luxury resort that offers comfortable modern lodgings with western flair and fine dining—all at the foot of the Tetons!

Below: A pair of red fox kits playfully adorn the porch at one of the park's many historic cabins.

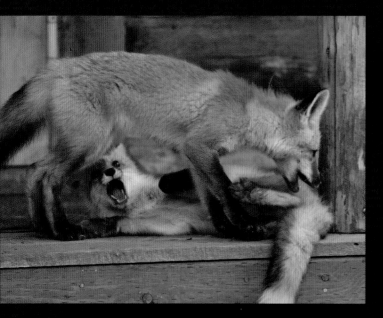

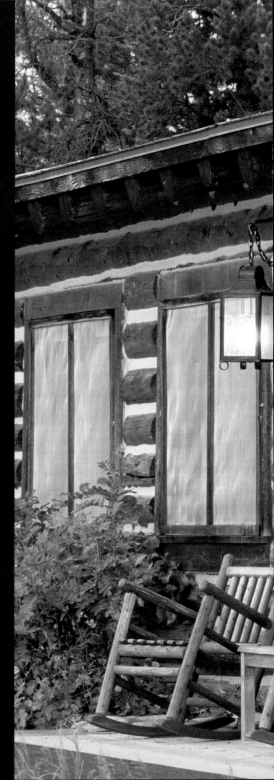

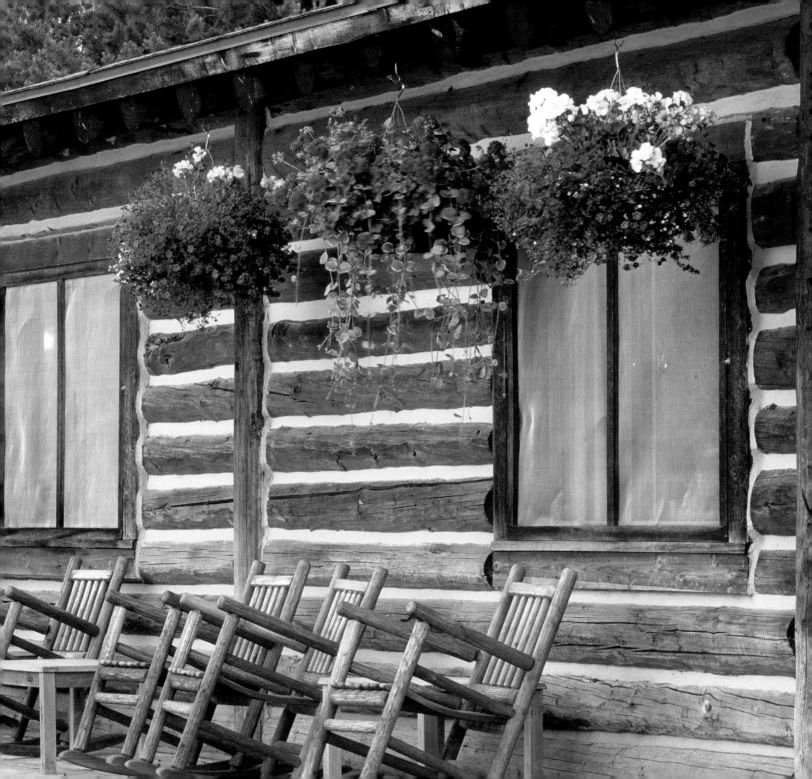

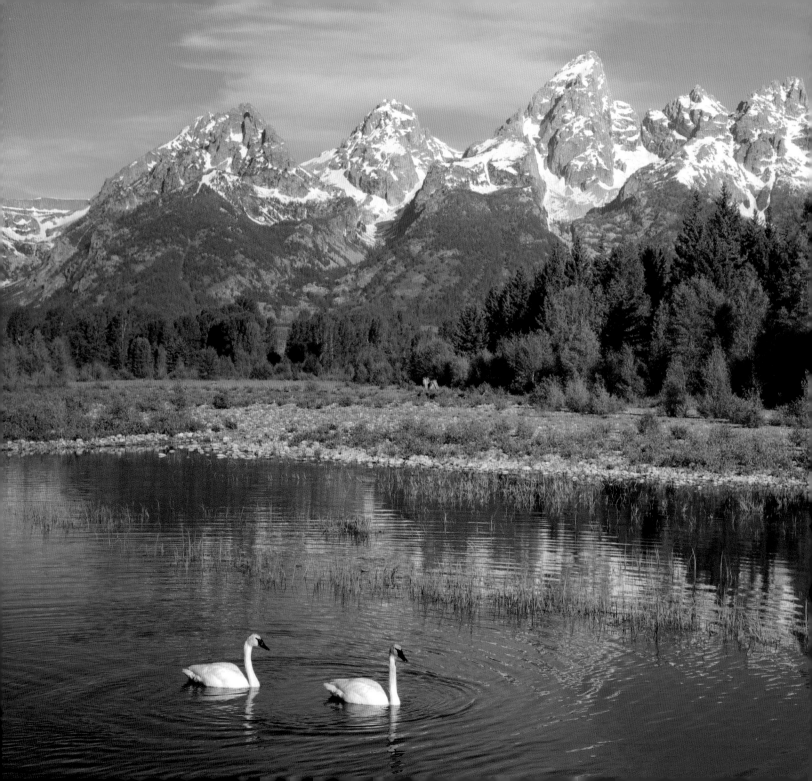

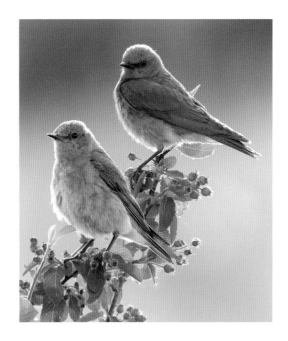

Above: A perfect match, a pair of mountain bluebirds sit side-by-side outside their nest along the Gros Ventre River. In over thirty-five years photographing in the valley, this was the only time I have ever had both sexes line up for a family portrait together.

Left: A pair of trumpeter swans makes a rare summer appearance on the beaver ponds at Schwabacher's Landing. Hunted to near extinction in the early 1900s, the isolated lakes and rivers of the Yellowstone Ecosystem provided a safe haven for the few remaining birds. Although still listed as a threatened species in the lower forty-eight states, these majestic birds can be found nesting on the National Elk Refuge and several small lakes and ponds in the valley.

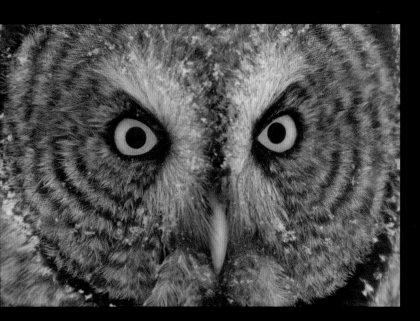

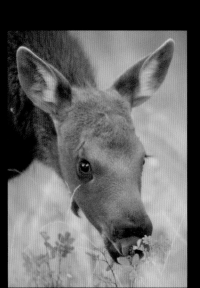

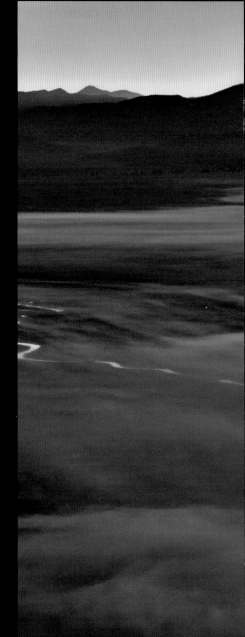

Above: The intense glare of a great gray owl shows he is focusing in on his prey, perhaps hearing a vole or pocket gopher under the snow. I watched his eyes become more and more yellow as he got closer to making his plunge. Owls with eyes that are yellow are more likely to be diurnal, meaning they most often hunt during daylight hours.

Right: A hungry moose calf nibbles on a meal of rosehips, a late summer treat.

Far right: A new day dawns over the feet of the Sleeping Indian as fog lingers over the many twists and turns of Flat Creek on the National Elk Refuge.

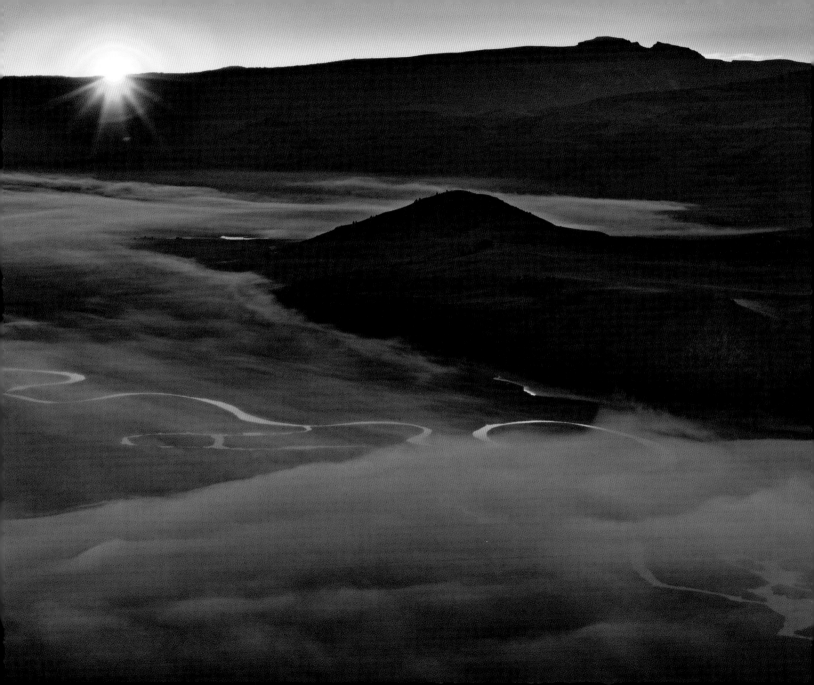

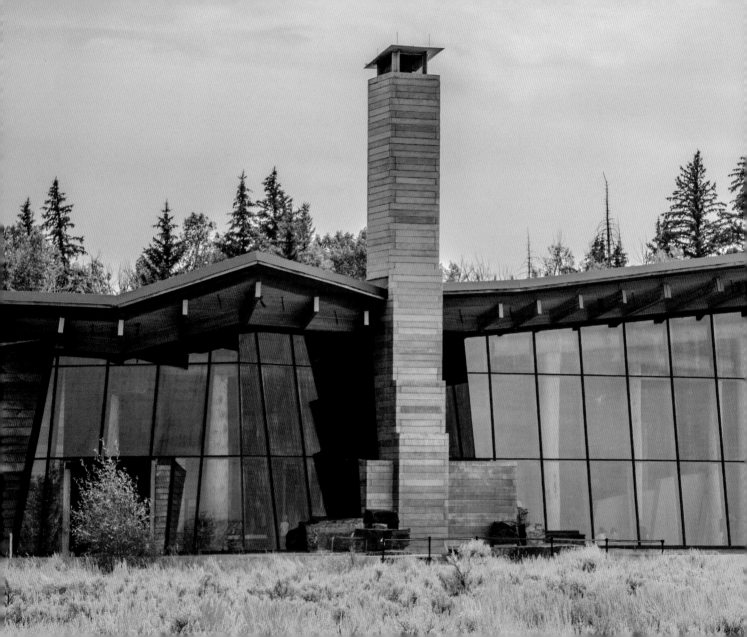

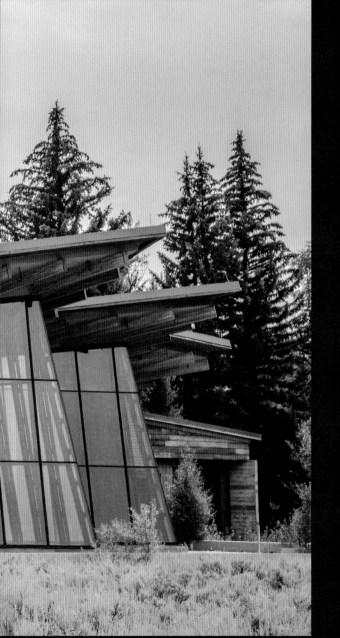

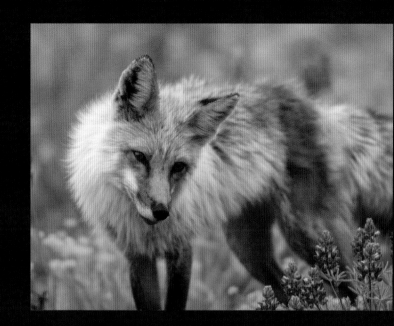

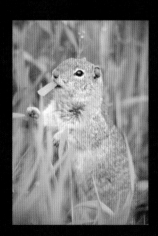

Above and left: A red fox pauses in a field of lupine to listen for a potential meal. The prey that it is most interested in at the moment is the uinta ground squirrel, seen here feeding on grasses. Ground squirrels are widely distributed throughout the park during the summer months, disappearing at the end of August to hibernate for the winter in their burrows.

Far left: The angular windows and roofline of the Craig Thomas Discovery and Visitor Center point toward a magnificent view of the Teton Range. Opened in 2007 and located at park headquarters in Moose, Wyoming, the visitor center is an excellent place to begin any trip into the Tetons.

Right: A male greater sage grouse struts his stuff across the snow at Antelope Flats. Year-round residents of the valley, this male was practicing his mating dance prior to the breeding season, which starts in April.

Far right: Frosted aspen trees find a haven of deep snow high up on the west slope of the Teton Range. One of the hardiest trees in North America, aspen can be found at many elevations and climates from the deserts of Mexico to the mountains of Alaska.

Below: A bull moose takes a break from feeding on bitterbrush during a heavy November snowstorm. I had watched this particular bull for several months throughout the fall rutting season, which lasts from mid-September through October. I had envisioned a photograph of him in a snowstorm, and the two of us spent the entire day together enjoying the peace and quiet of the falling snow.

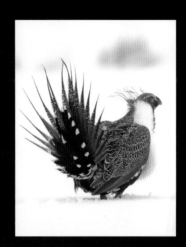

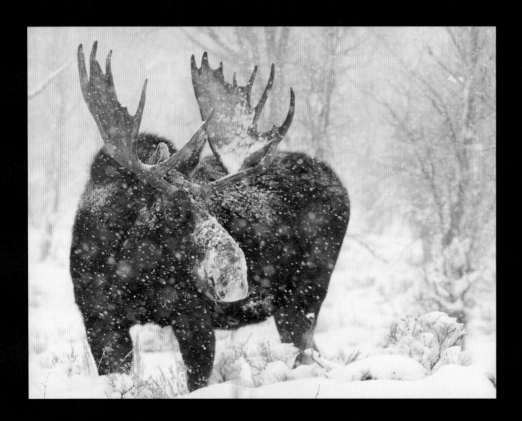

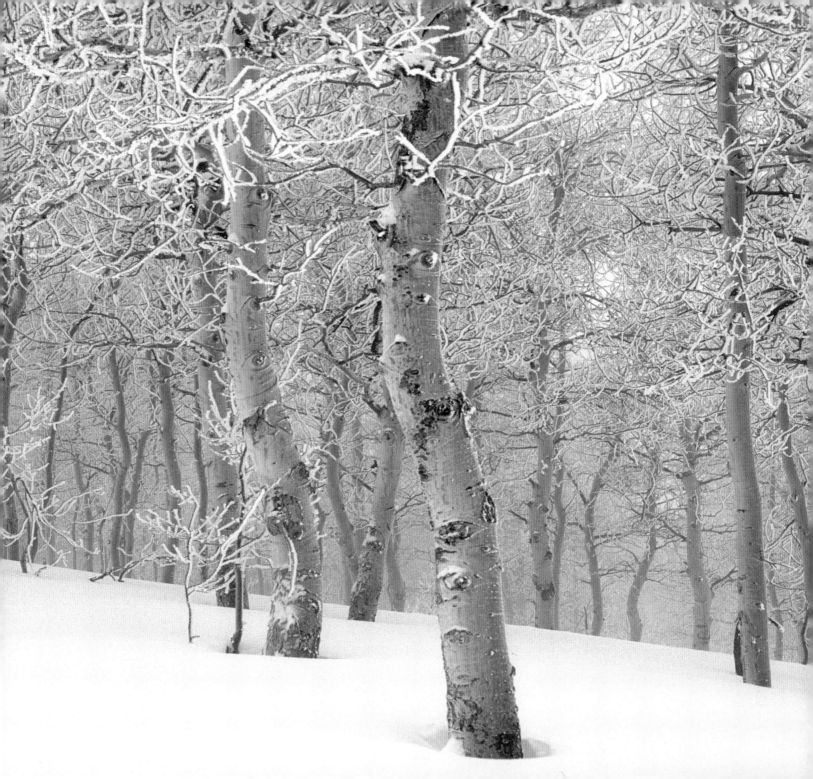

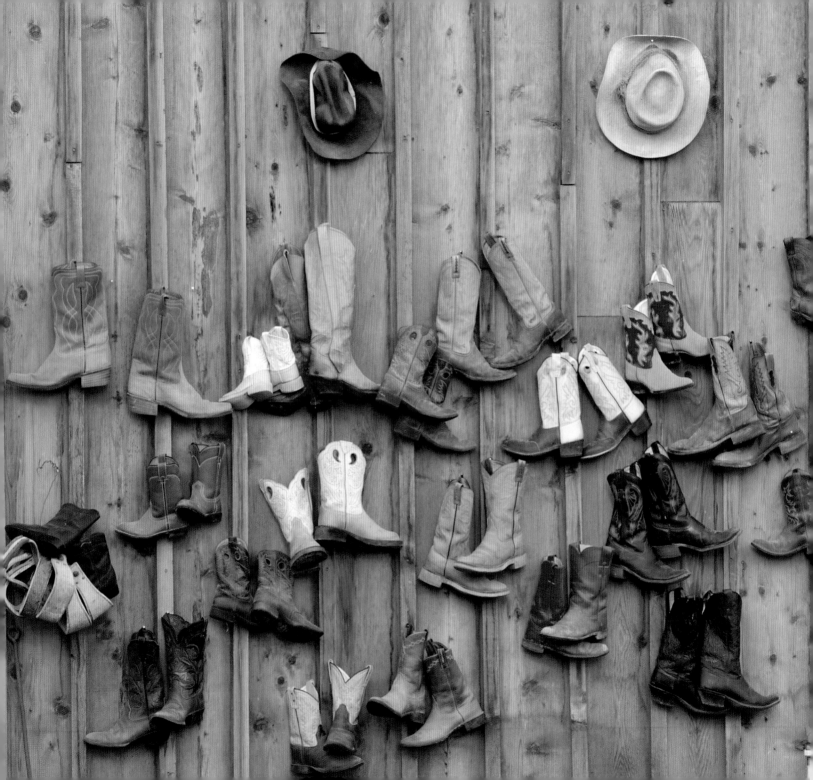

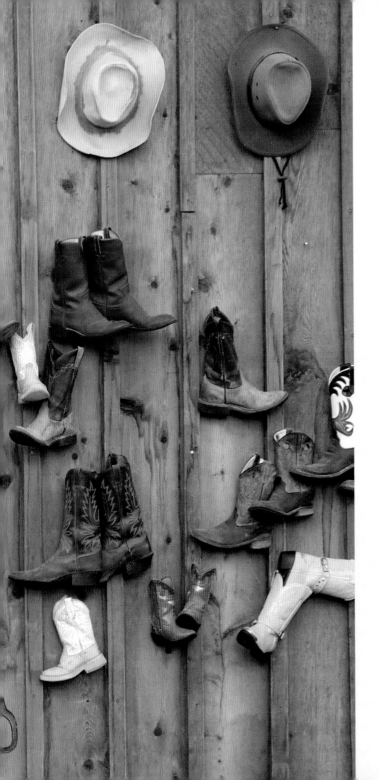

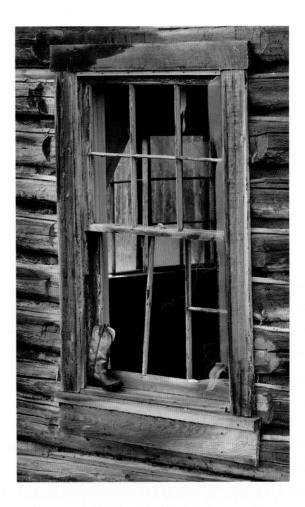

Above: A sign of days gone by, an old cowboy boot rests in a cabin window at the Elk Ranch. In its heyday from around 1908 to 1928, the Elk Ranch was the largest cattle operation in the valley encompassing over 3,600 acres. It was sold in 1928 to the Snake River Land Company, owned by John D. Rockefeller, and was included in the original portion of land that would become Grand Teton National Park in 1929.

Left: The cowboy way is alive and well in Jackson Hole, as is illustrated by this whimsical collection of boots and hats.

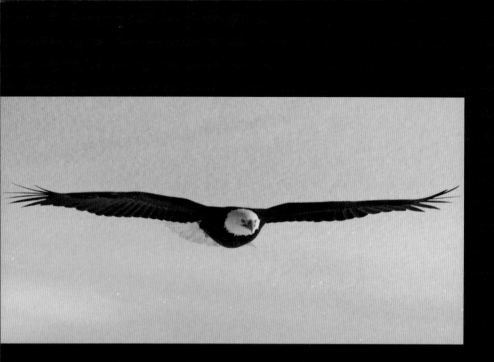

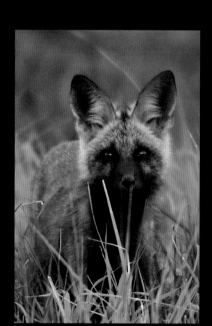

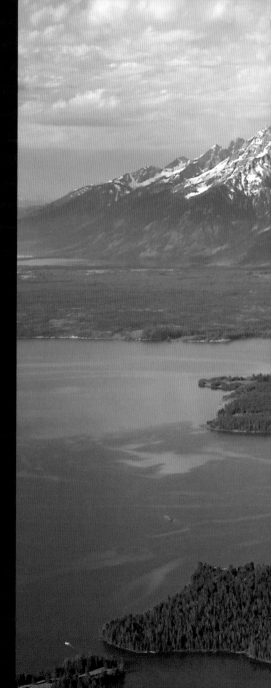

Above: A bald eagle swoops in low over the frozen Snake River to try and steal a meal from a nearby family of river otters.

Right: A curious adult cross fox comes to check out the photographer watching its den. There are two color phases of the red fox that live in Jackson Hole. One is the normal red or orange color, and there is also a less common black color phase known as a silver fox. This cross fox is a result of one parent who was red and one who was black, giving it a mixture of the two.

Far right: From high above Colter Bay, an aerial view of Jackson Lake and the Teton Range looks over Half Moon Bay with Elk Island in the distance.

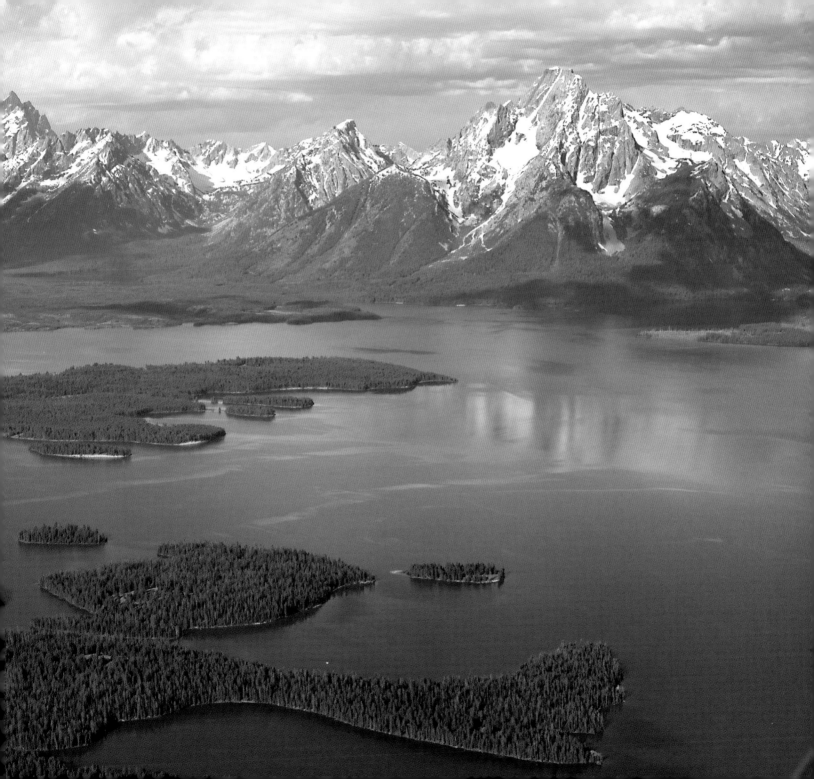

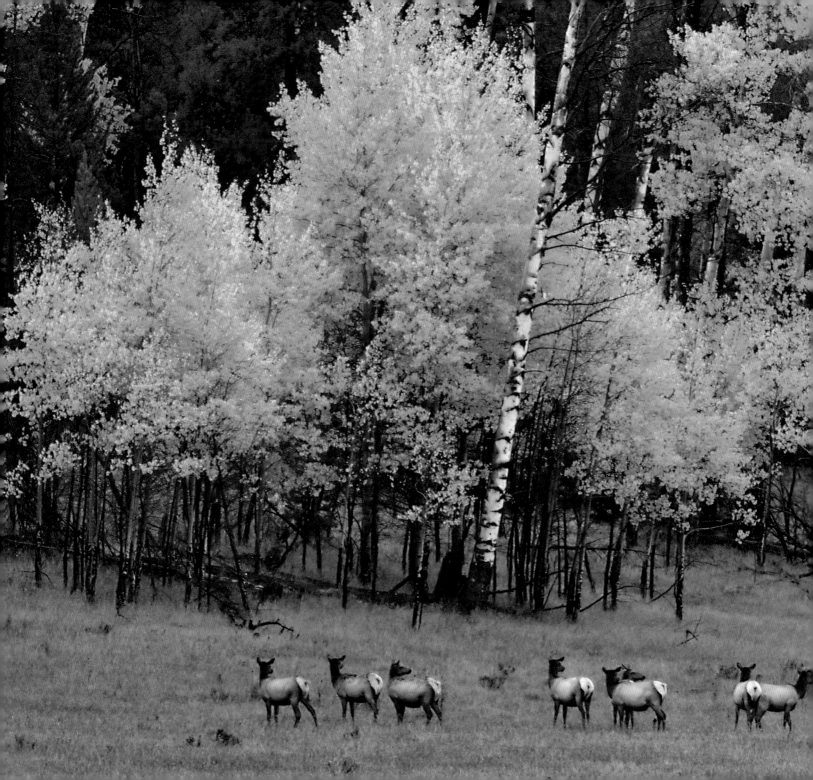

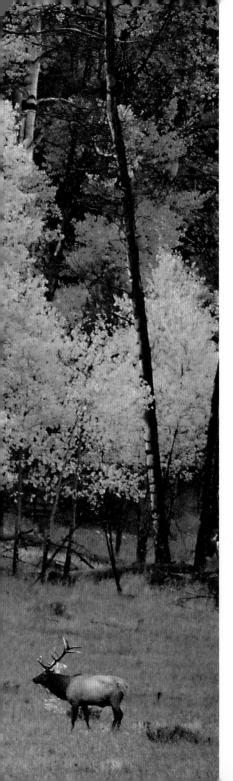

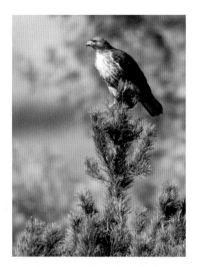

Left: A red-tailed hawk finds a good perch to look for rodents in the meadow below.

Far left: I watched this bull elk tussle with an aspen tree until he had lodged a sizable branch in his antlers. Feeling good about his new look, he headed toward his harem to impress the ladies. Unfortunately for him, his group of cows became scared of his new decoration and quickly turned and ran away.

Below: A large bull bison wanders along the buck and rail fence near the Moose Head Ranch south of Moran Junction.

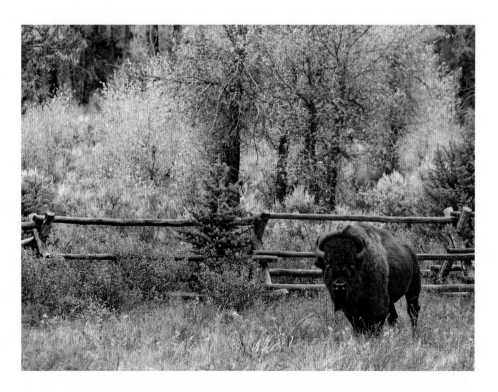

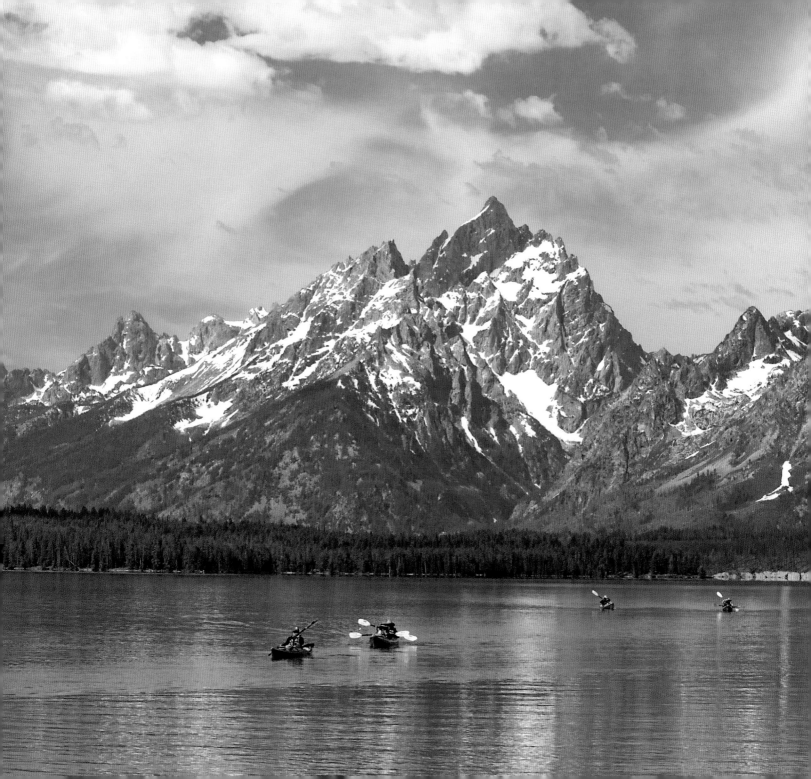

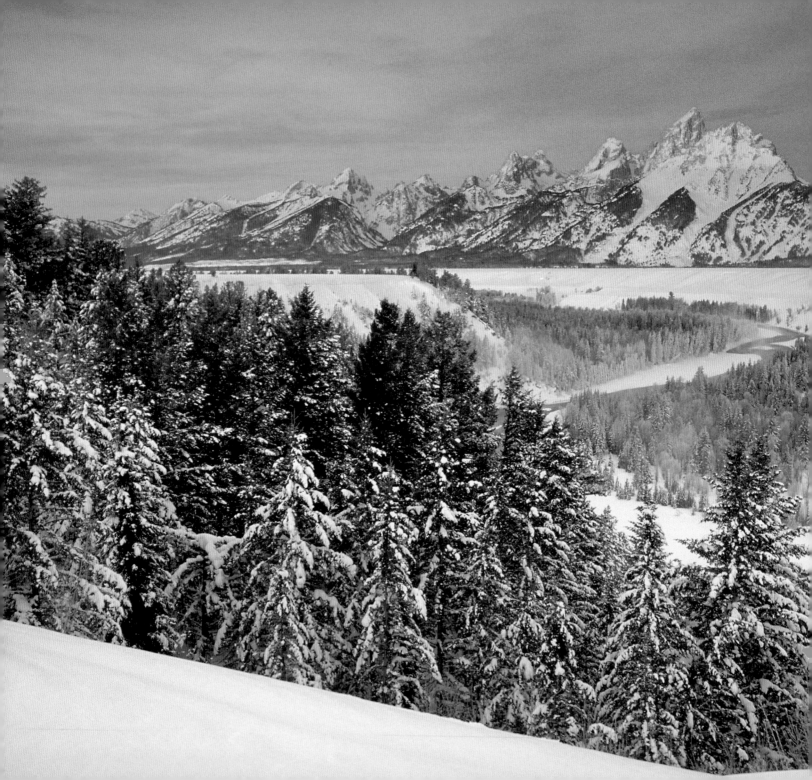

Left: Larkspur is one of the first wildflowers to bloom each spring; this larkspur is greeted with a snowy blanket in May.

Far left: A coating of fresh snow and the bright hues of alpenglow greet the first light of the day along the Teton Range as the Snake River winds its way through the valley called Jackson Hole.

Below: A year-round valley resident, this male Barrow's goldeneye finds open water in Flat Creek on the National Elk Refuge.

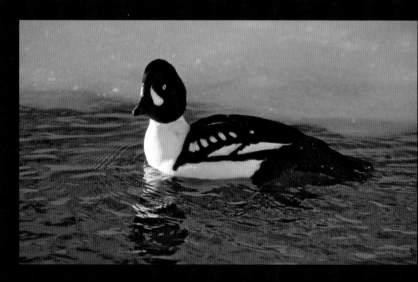

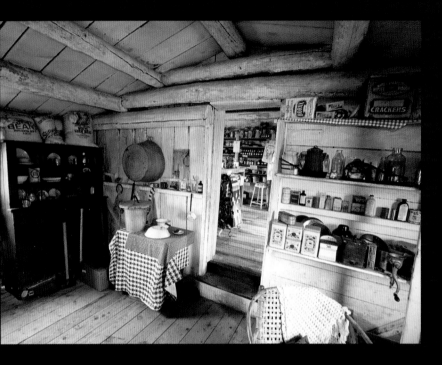

Above and far right: Homesteaded in the 1890s by Bill Menor, Menor's Ferry with its store and blacksmith shop was the hub of activity in Moose prior to the bridge being built in 1927. The store is still open for business each summer and run by the Grand Teton Association.

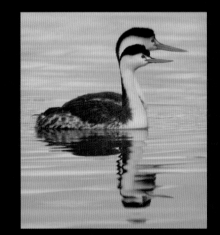

Right: A pair of western grebes mirror each other at Oxbow Bend. Jackson Lake in the spring and Two Ocean Lake in summer are other predictable locations to view these charming birds.

Next pages: A stampede of horses rushes for pasture at the Triangle X Ranch. Run by five generations of the Turner family, the dude ranch has been operating in the Tetons for over ninety years.

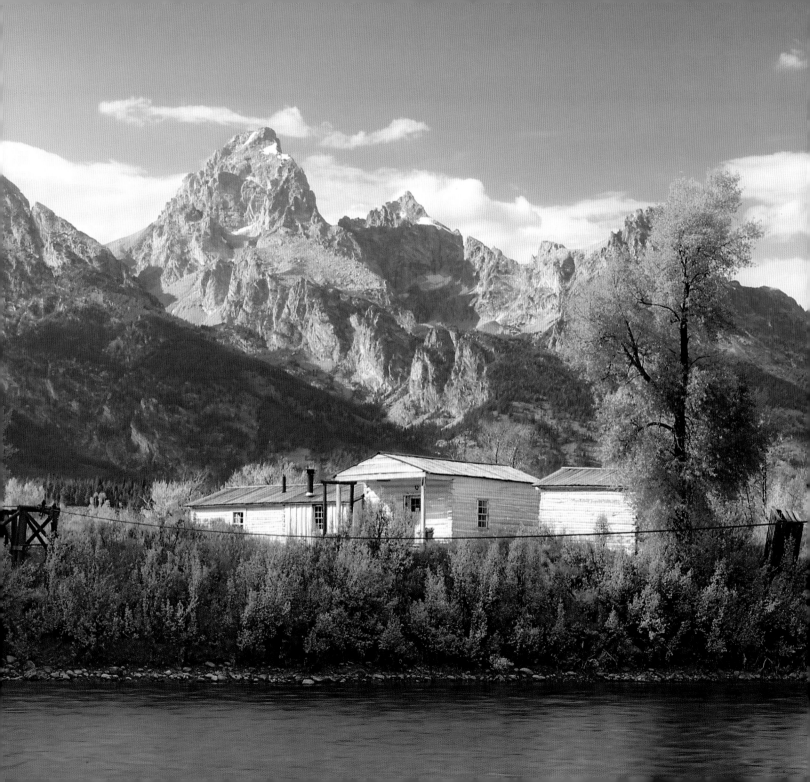

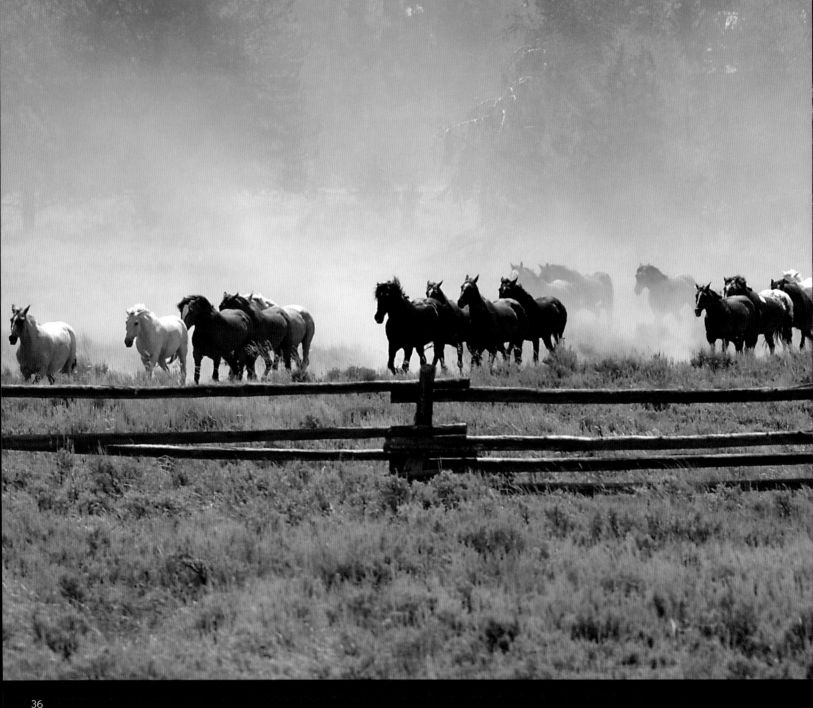

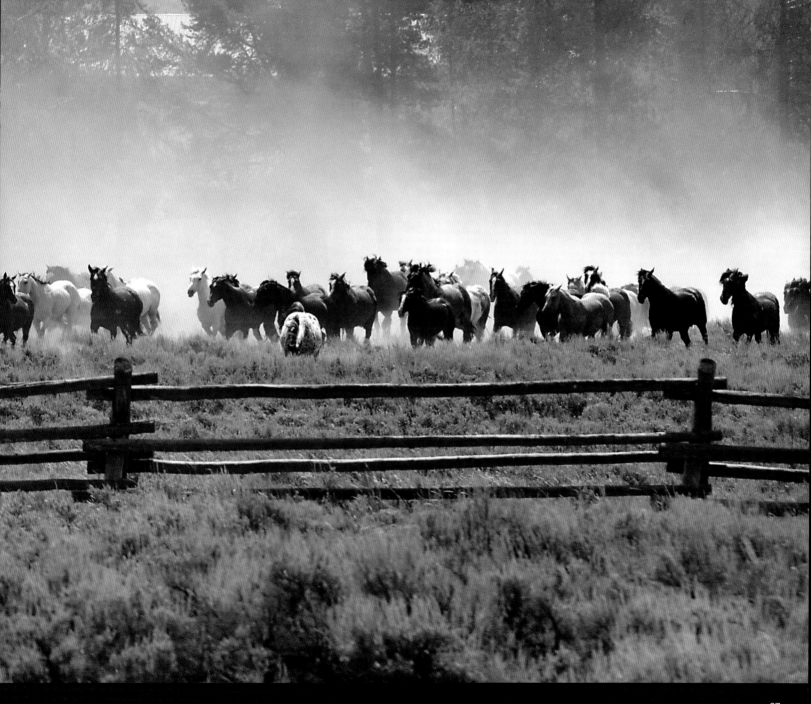

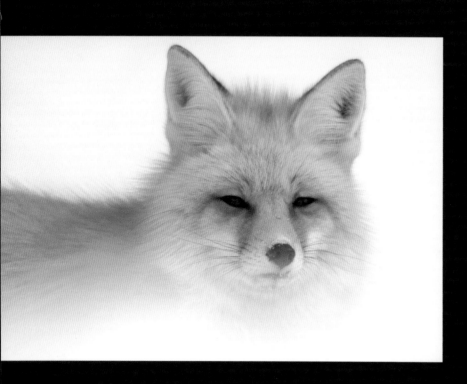

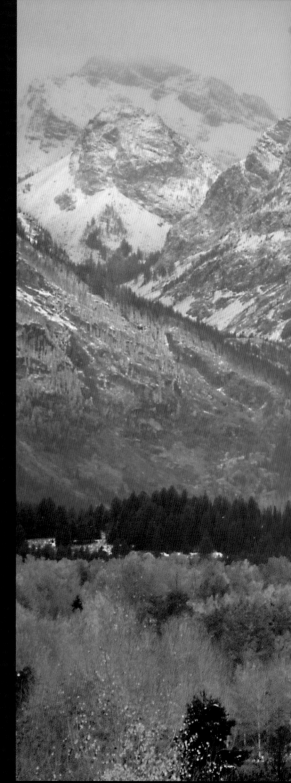

Above: A red fox in all its winter finery peaks over a snow bank near Colter Bay.

Right: While out exploring one day, I stopped for lunch near a rocky slope that looked like great pika habitat. As I ate my lunch, sure enough the resident pika came over to check me out, becoming more and more curious. With each pass of carrying grasses to his haystack, he came closer and closer until I finally captured this image. It turned out to be my lucky day to have lunch with a pika.

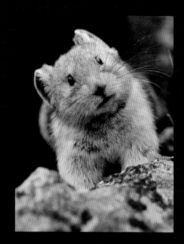

Far right: A dusting of September snow coats the slopes of Bivouac Peak at the mouth of Moran Canyon, as aspen trees dot the valley below around Oxbow Bend.

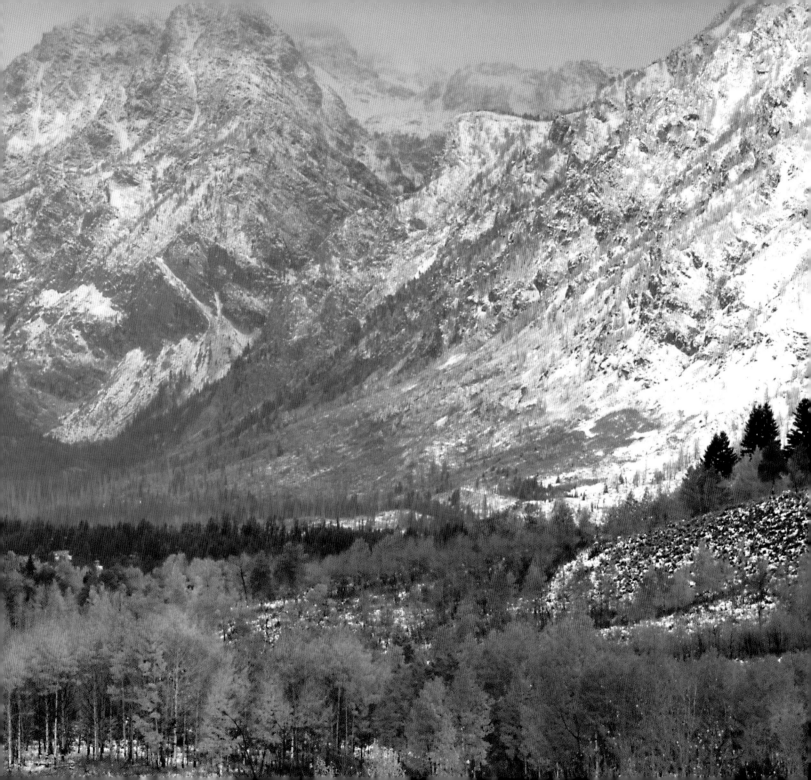

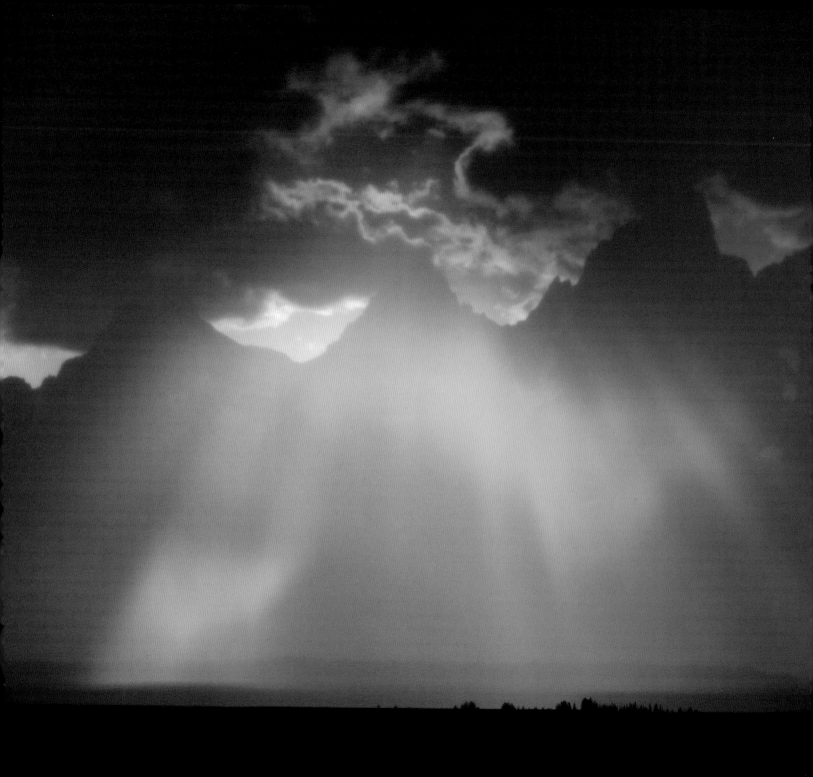

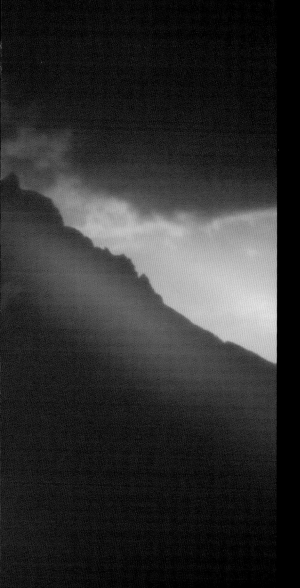

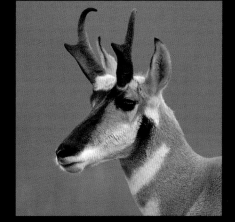

Left: A pronghorn buck checks its surroundings near Mormon Row. Pronghorn are the fastest mammals in North America, reaching speeds of over 60 miles per hour.

Far left: Rays of light shower the Tetons as an evening thunderstorm passes over the mountains in front of Lost Creek Ranch.

Below: Backlit steam and heavy breathing surround a courting pair of moose along the Gros Ventre River.

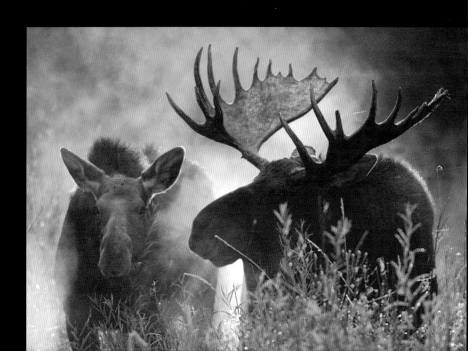

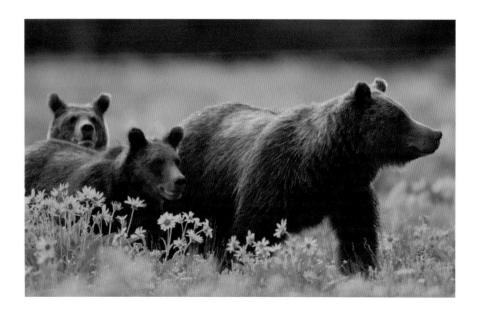

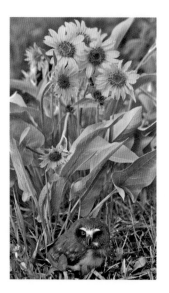

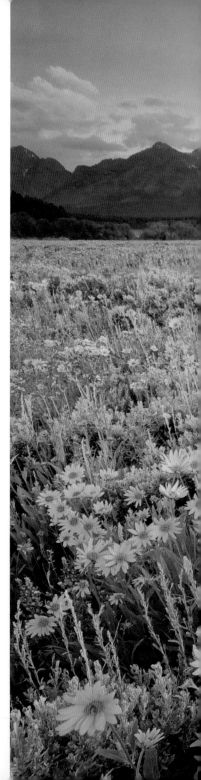

Above: Grizzly bear 399 and her cubs take an early morning stroll through a meadow of arrowleaf balsamroot near Pilgrim Creek. Bear 399 is Grand Teton's most famous bear, not only for raising three sets of triplets in a row over a ten-year span, but because she spends much of her time in places that are readily viewed by park visitors when she has a litter of cubs in tow.

Right: A saw-whet owl chick finds refuge under a bouquet of balsamroot near the Teton Science School in Kelly.

Far right: Fields of gold are the bounty of an extremely wet spring that leads to an explosion of wildflowers in the sage meadows of Antelope Flats. One-flower sunflowers dominate the scene accompanied by a healthy mix of blue penstemon and sticky geranium.

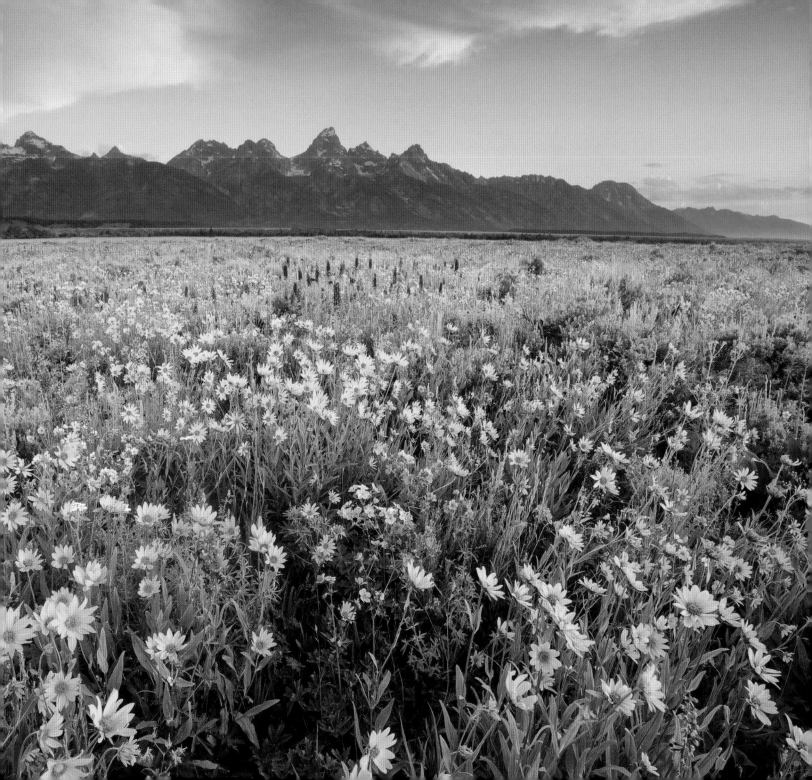

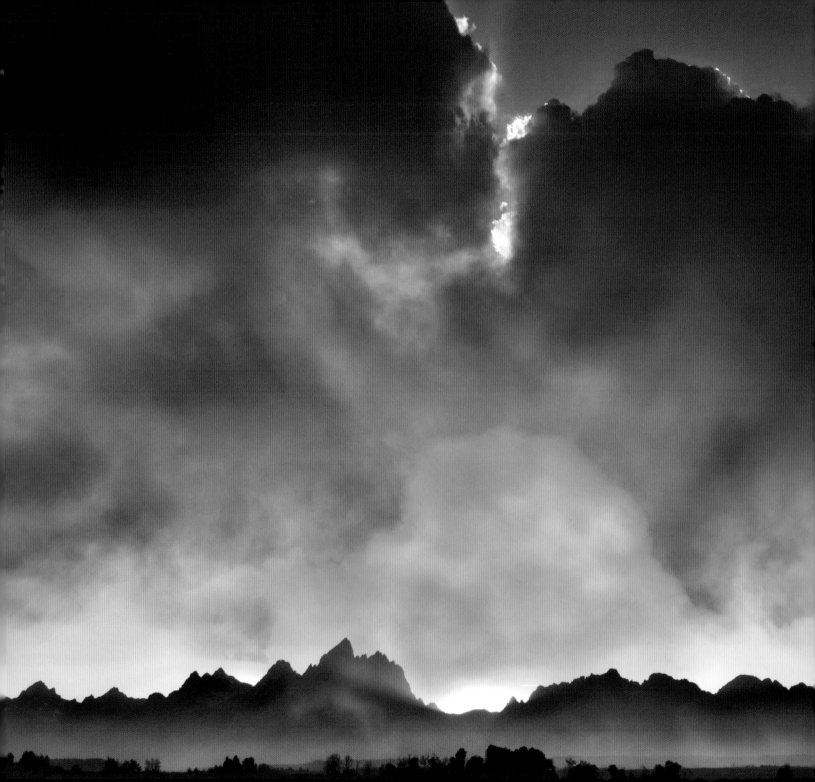

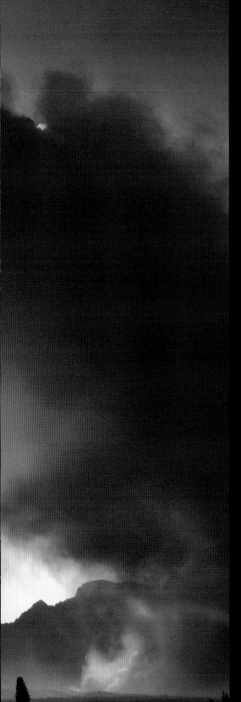

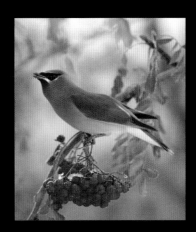

Left: A cedar waxwing enjoys a holiday feast as it dines on a December banquet of mountain ash berries.

Far left: The Bearpaw Bay Fire puts out a plume of smoke, making for a dramatic sunset as it swirls over the Teton Range. Caused by a lightning strike a month earlier and suppressed by firefighters, it blew up this September day after high winds rekindled the blaze. Naturally occurring forest fires play an important role in the ecology of the ecosystem.

Below: A bull moose shows off his antlers after having shed his velvet in September. Moose are the largest member of the deer family, and this bull will drop his antlers each winter and begin growing a new set each spring.

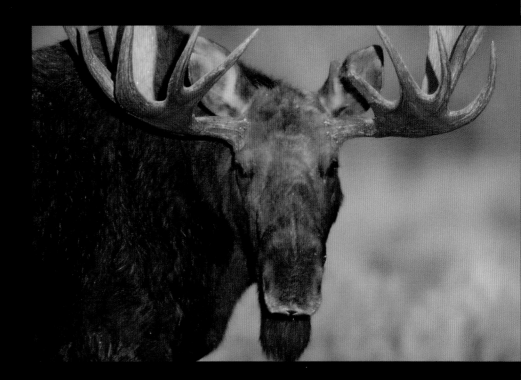

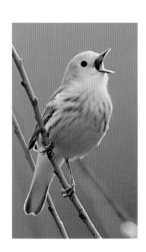

Right: A male yellow warbler sings his heart out from a willow branch up Pacific Creek.

Far right: Arrowleaf balsamroot brightens the foreground in front of Mount Moran along the shoreline of the Snake River at Oxbow Bend.

Below: This mule deer fawn pauses to scratch her chin while trying to keep out of sight near Signal Mountain.

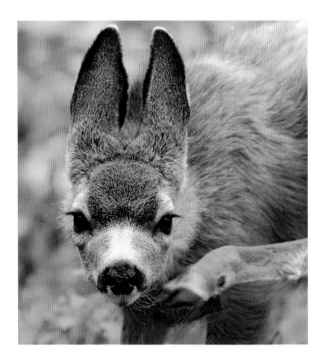

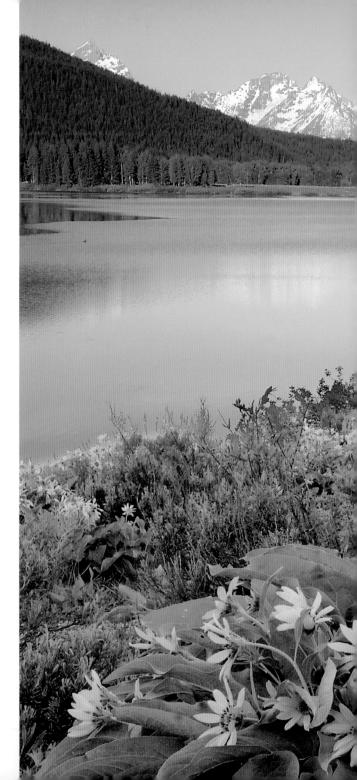

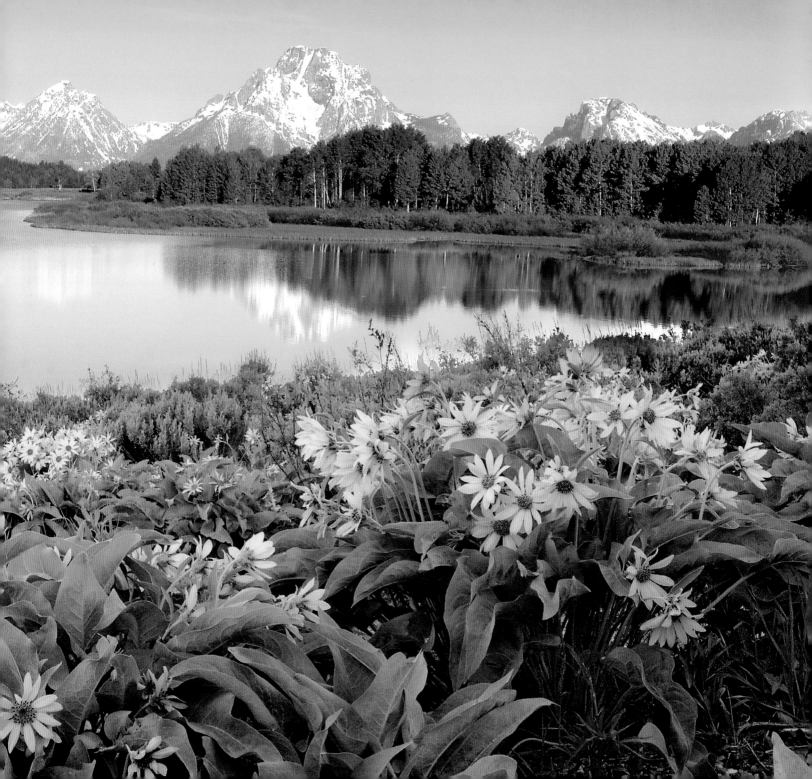

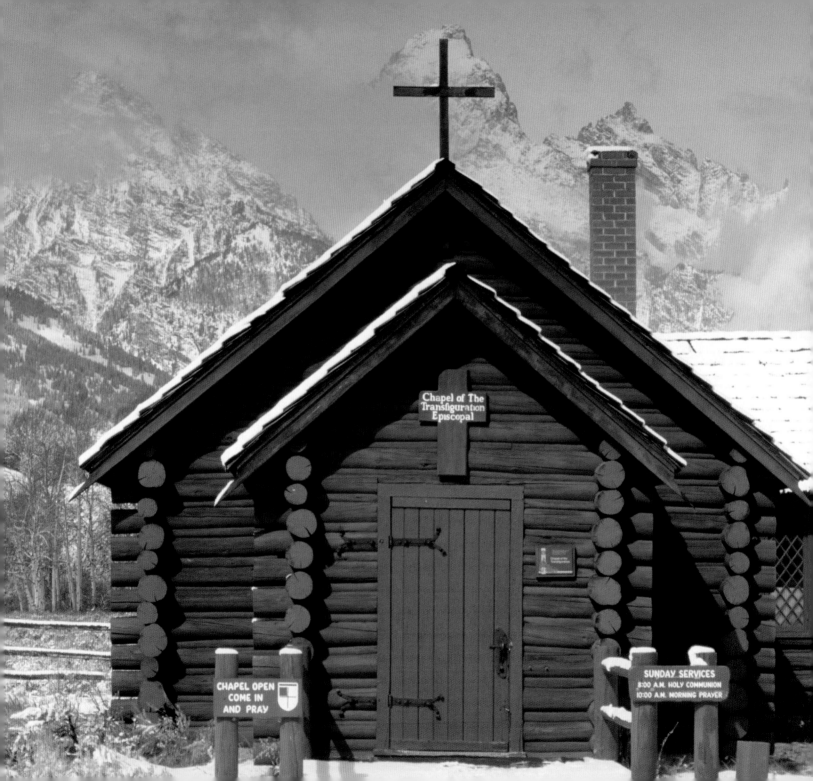

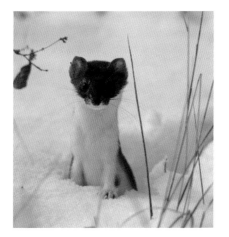

Left: While teaching a photography workshop at The Murie Center, I was intrigued by this long-tailed weasel that was living in the woodpile. On the final day of the workshop, it snowed, and I caught him still in his summer coat. Within eight days, he would change over to his white winter coat and go by the name of ermine.

Far left: An early dusting of snow coats the Chapel of the Transfiguration in Moose, Wyoming, signaling that winter is not far behind.

Below: This full-curl bighorn sheep ram was ready for a battle near Miller Butte on the National Elk Refuge. The rifle shot sound of butting heads can be heard throughout the rut during the months of November and December.

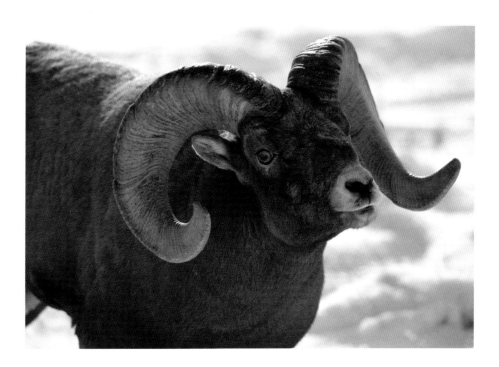

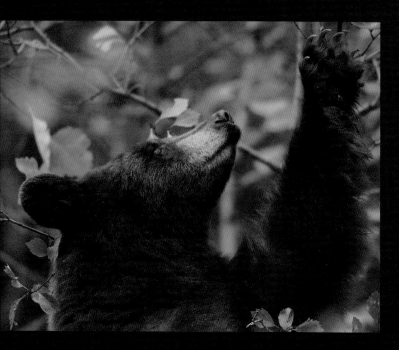

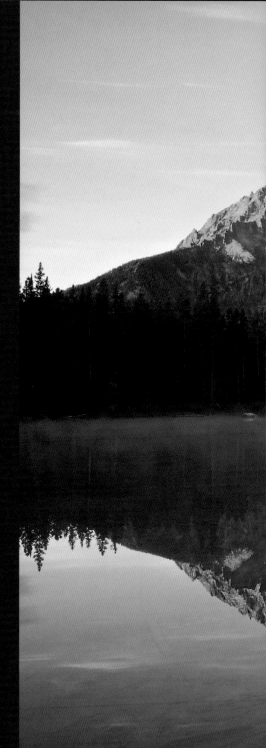

Above: A black bear reaches for the berries of a hawthorn bush along the Moose-Wilson Road.

Right: The familar tale of the one that got away—a young northern harrier pauses after mistiming his dive for a rodent in the tall grass.

Far right: A perfect reflection is mirrored in the waters of String Lake at the base of the Tetons.

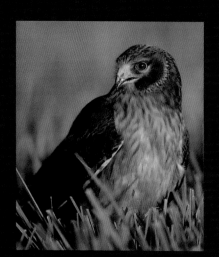

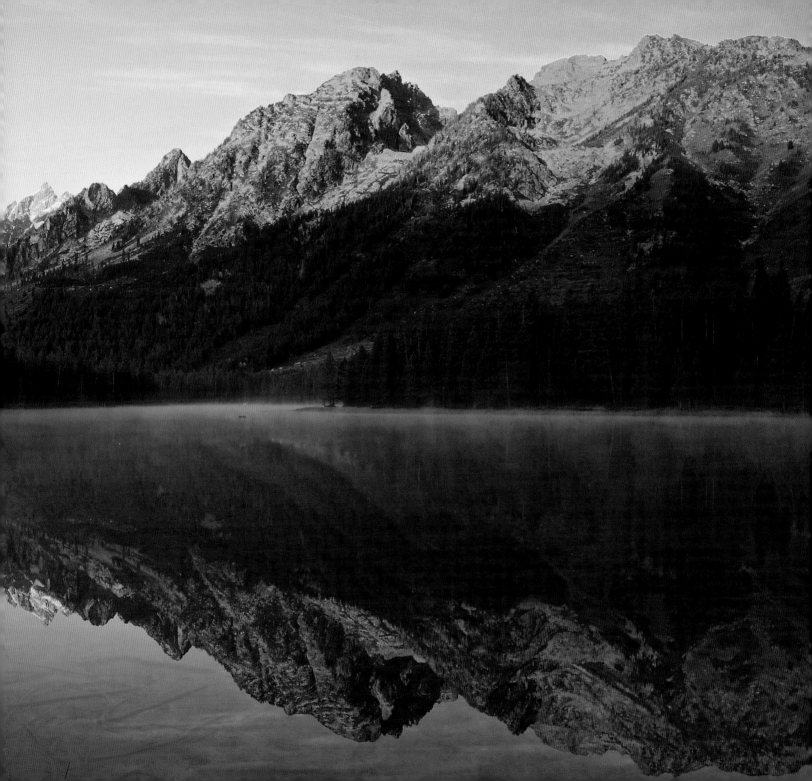

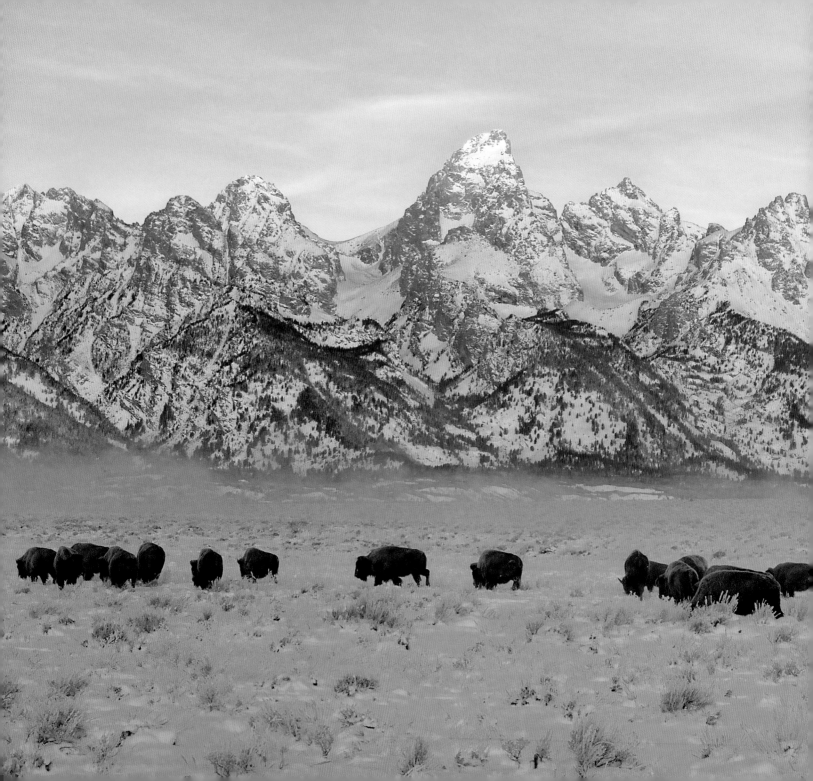

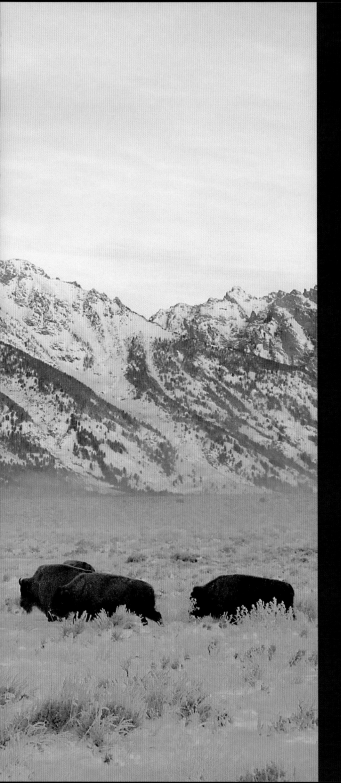

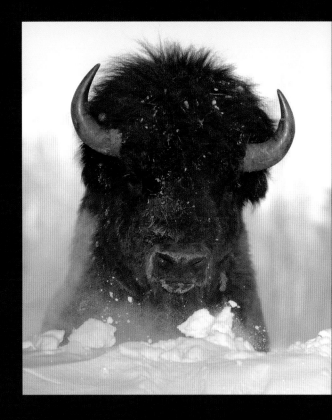

Above: Busting out of a mound of deep and crusty February snow, this old bull elected to stay behind the herd and tough out the winter near Moran. Older bulls are often solitary or wander in small bachelor groups, joining the rest of the herd only during the fall rut.

Left: As the first light of the day strikes the Grand Teton, a herd of bison crosses the Kelly Hayfields on their way toward winter range on the National Elk Refuge.

Right: The top of a showy green gentian stalk makes an excellent perch for this curious song sparrow.

Far right: A dam marks the presence of beavers at Schwabacher's Landing as Mount Moran dominates the background.

Below: A beaver dines on a meal of aspen leaves and twigs along the Moose-Wilson Road. The largest members of the rodent family, adult beavers can weigh up to ninety-five pounds. They are mainly nocturnal in their feeding and dam building endeavors, working primarily between the hours of 6 P.M. and 6 A.M., and sleeping during the day in their lodge.

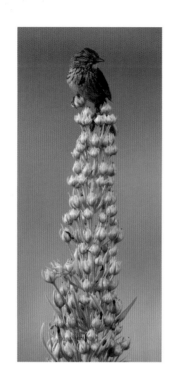

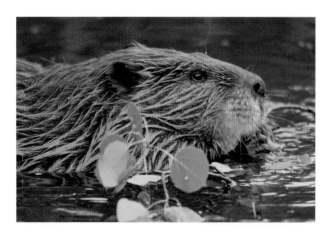

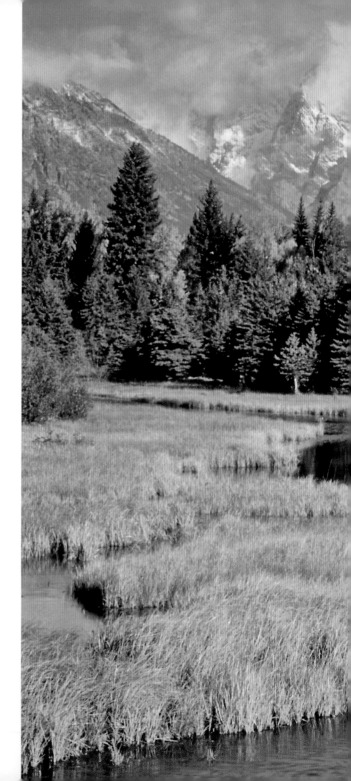

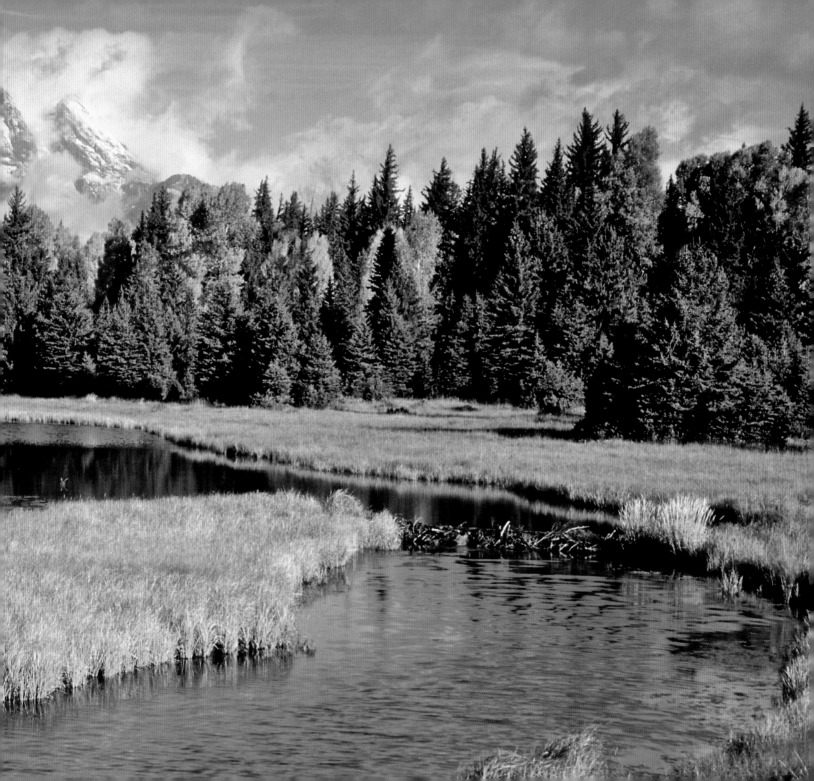

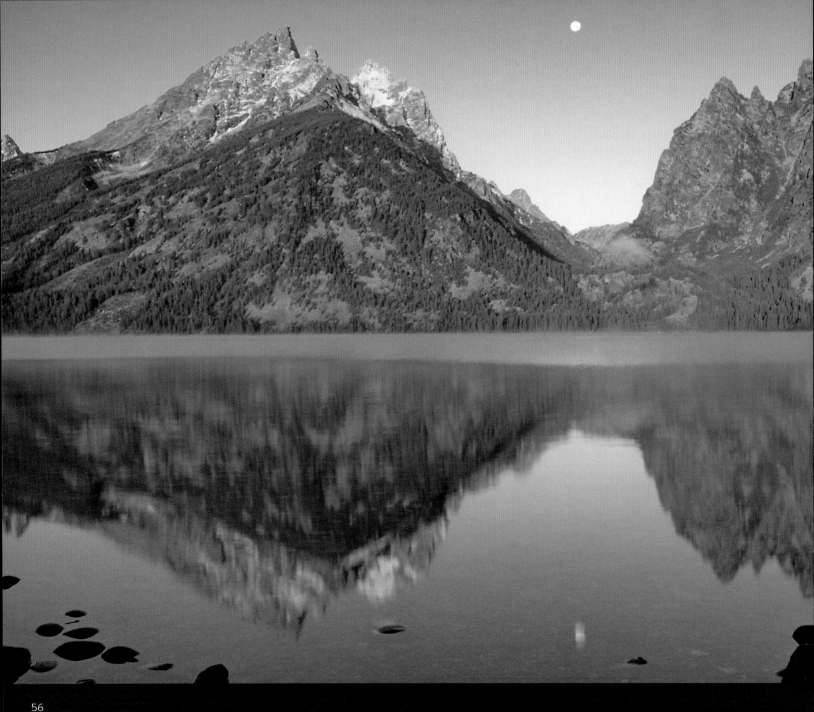

Left: A belted kingfisher finds a handy perch above Pacific Creek.

Far left: The full moon sets through Cascade Canyon as Mount Teewinot and Symmetry Spire are reflected in Jenny Lake. The lake is named for the wife of early trapper Beaver Dick Leigh, who also named Leigh Lake just to the north.

Below: A mother mountain lion and her kitten stare out from their den over the plains of the National Elk Refuge. A wolf howling on the other side of the refuge is what piqued their interest. As elk migrate to the refuge each winter, so do the predators as they follow their quarry. Mountain lions are mainly nocturnal in their habits, and sightings are rare. In this instance, her three kittens gave away her location on Miller Butte due to their youthful exuberance.

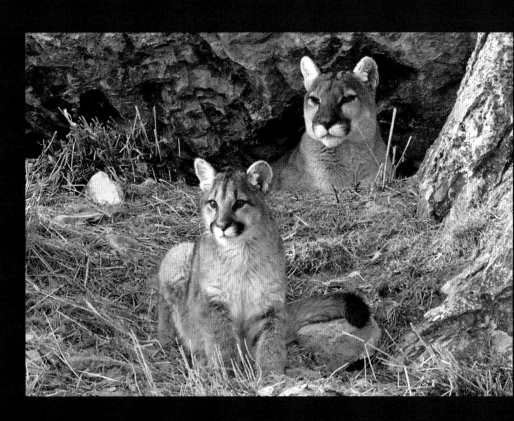

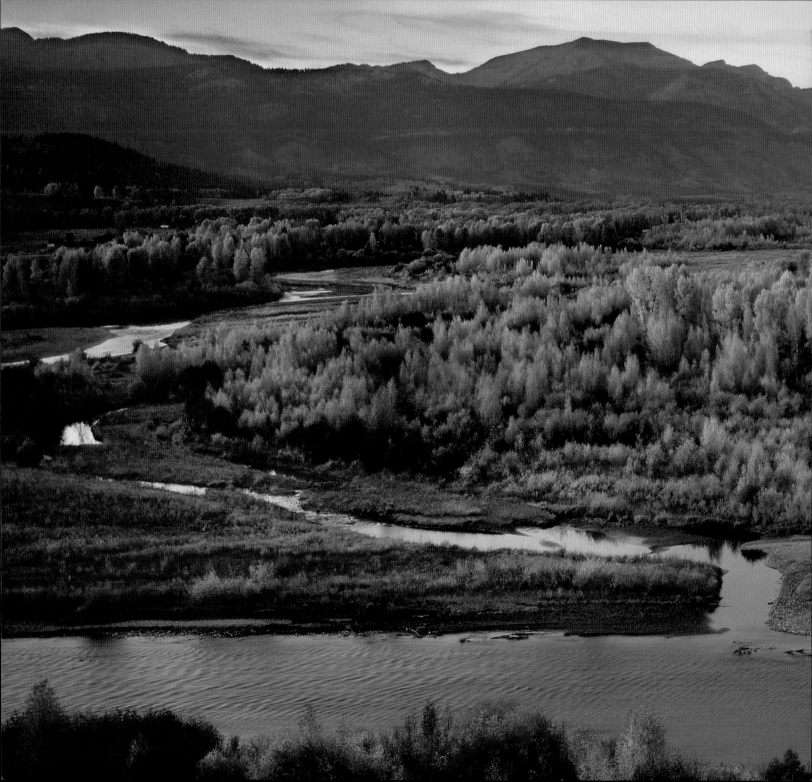

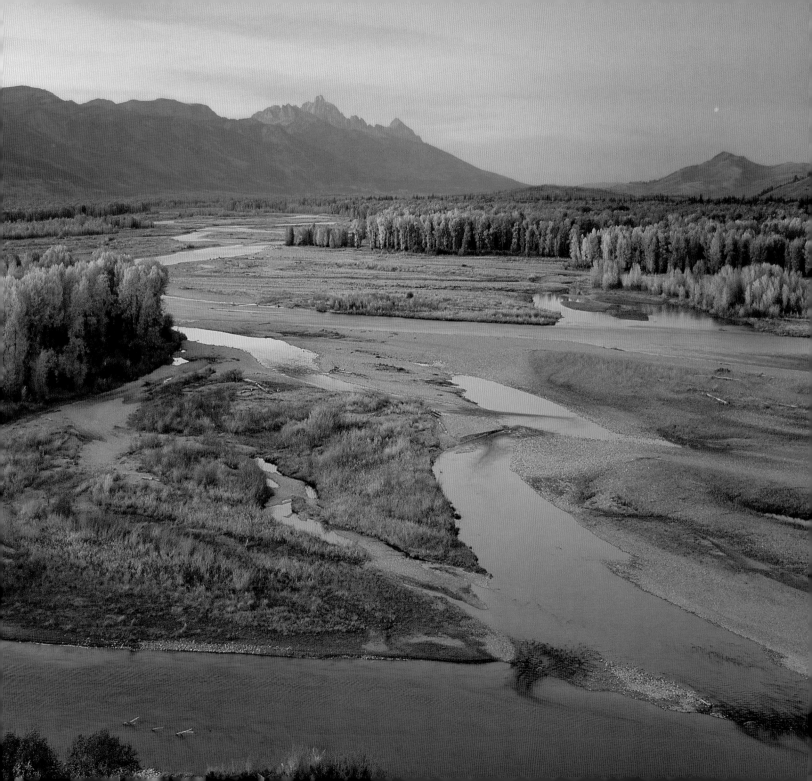

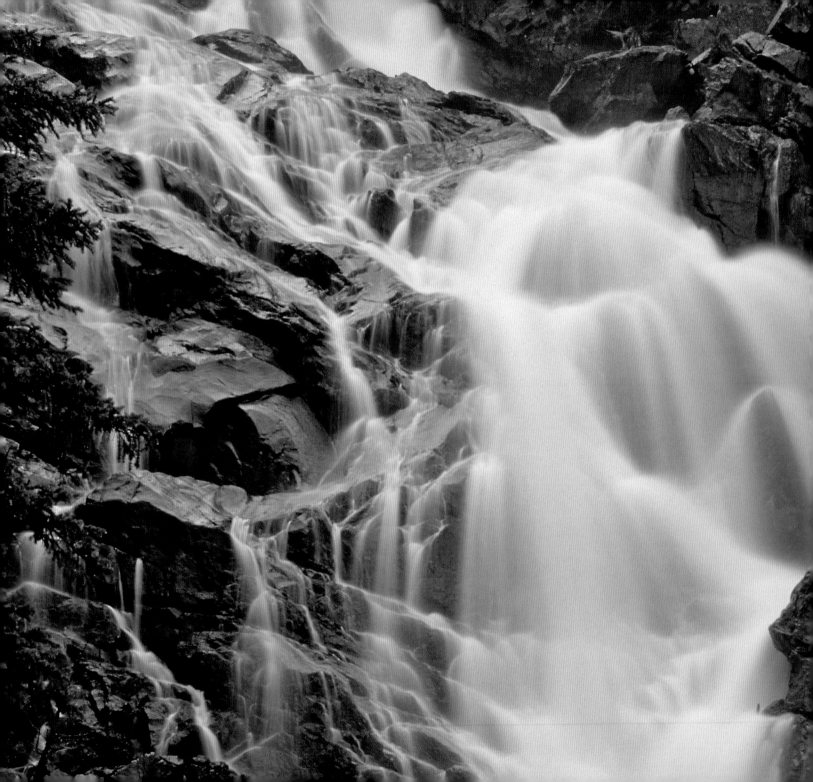

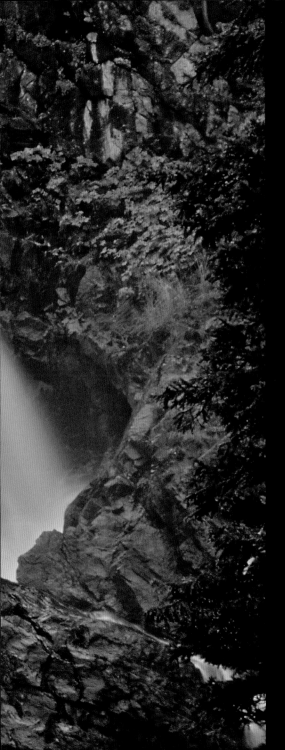

Previous pages: The brilliant colors of fall highlight the many channels of the Snake River as it winds its way south through the Jackson Hole Valley.

Left: Wolf tracks skirt the edge of a lake in Grand Teton National Park. Signs of wildlife can be found everywhere in the park, even if you don't see the animal that left them behind.

Far left: Hidden Falls, on the west shore of Jenny Lake, is a popular destination on the way to Inspiration Point and Cascade Canyon.

Below: Two ravens patiently wait their turn to dine on a kill left by wolves.

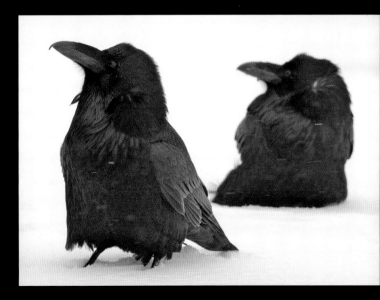

Right: A young female grizzly, affectionately known to the locals as Blondie, makes her way through a meadow near Pilgrim Creek.

Far right: After eating her fill of hawthorn berries, this large female black bear soaks it all in while cooling off in a pond on the Laurance S. Rockefeller Preserve.

Below: The home of Mardy and Olaus Murie, two giants in the field of conservation, is located in Moose, Wyoming, and is listed on the National Register of Historic Places. Now home to The Murie Center, the ranch serves as inspiration for conservation, and provides a place for people to come together with ideas for action to protect the environment.

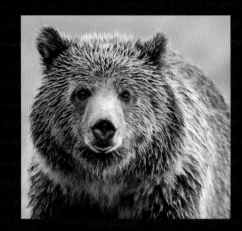

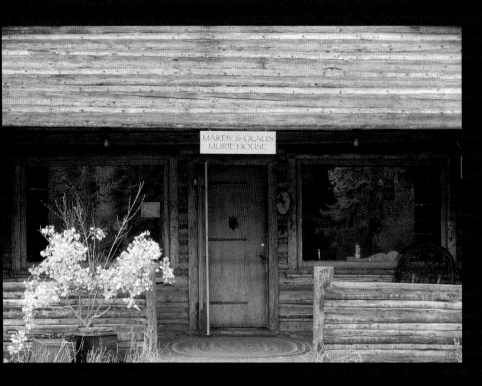

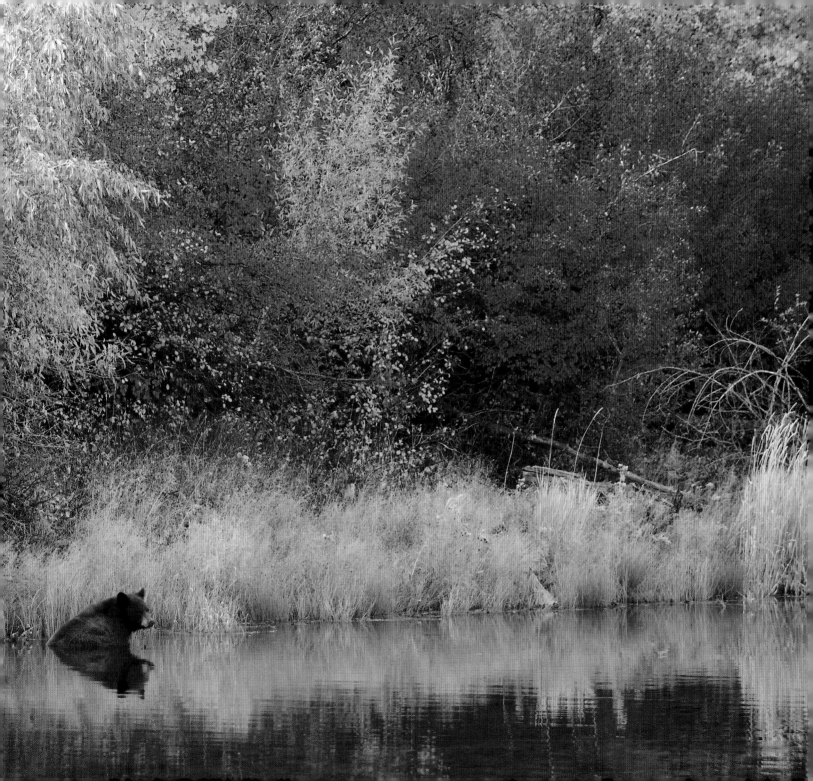

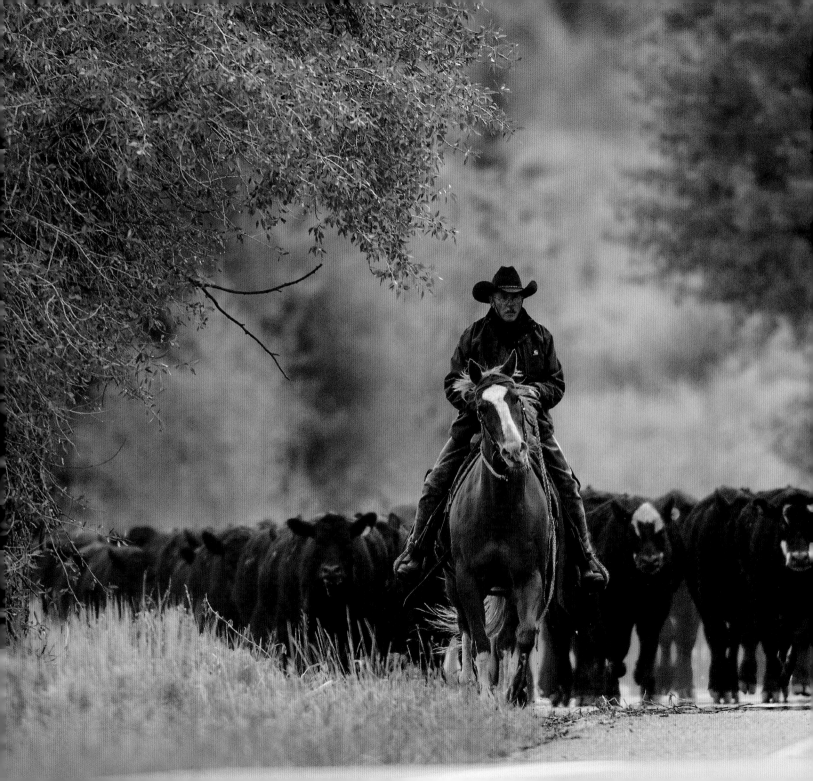

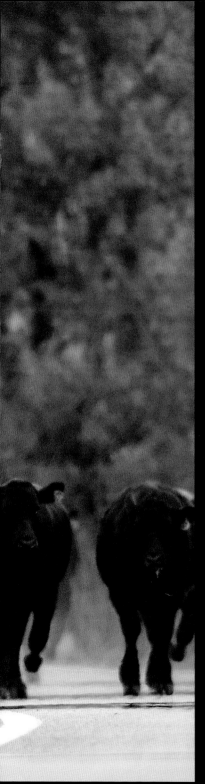

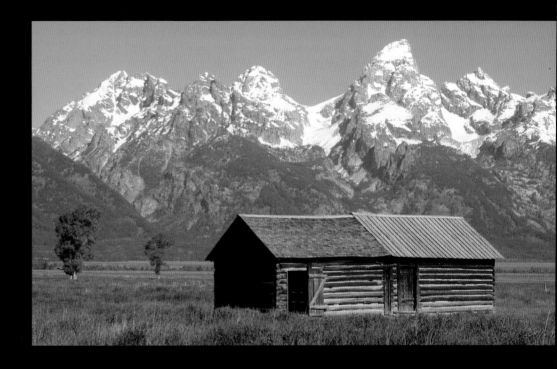

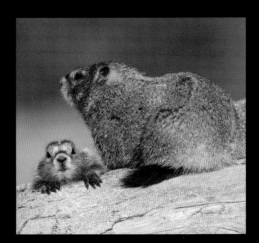

Above: Mormon Row Historic District, listed on the National Register of Historic Places in 1997, offers a glimpse into the past with clusters of structures that stand as a reminder of the close-knit community settled here by Mormon homesteaders in the 1890s.

Left: Under his mother's watchful eye, a baby yellow-bellied marmot emerges from its den inside a fallen Douglas fir tree. Grand Teton National Park is the only place I have seen marmots living in trees.

Far left: Wranglers from the Pinto Ranch drive their cattle down Highway 89/191 each June to access their grazing allotment at Elk Ranch Flats. Cowboys and cattle ranching have a rich history in all portions of the valley.

65

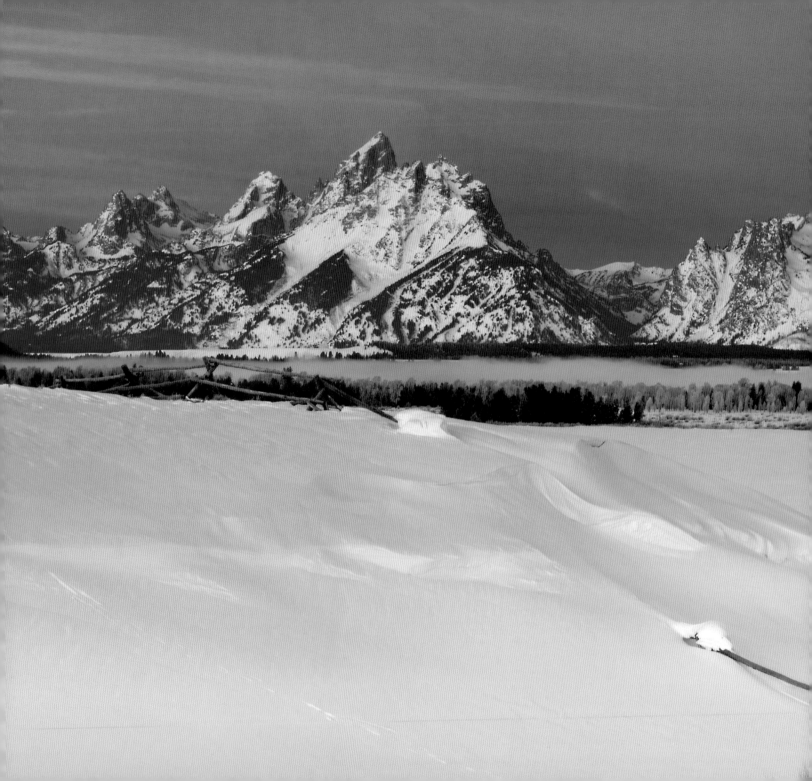

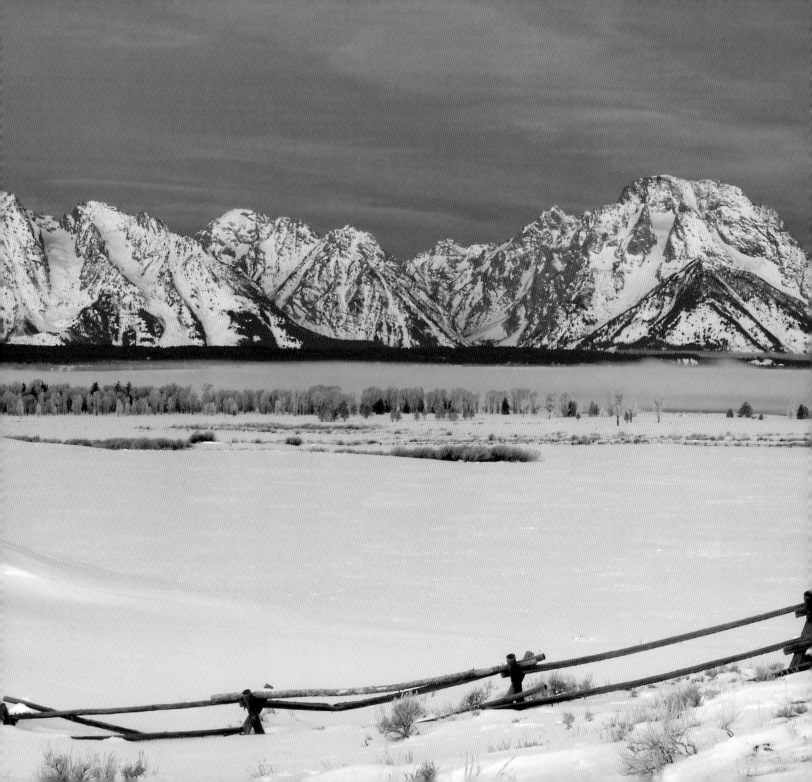

Previous pages: Fence-high snowdrifts mark a good winter on a 28 degrees below zero morning at the Triangle X Ranch.

Right: Dried grasses add a nice touch to the nest of this hovering osprey. Osprey typically build their nest near water so they can hunt for fish.

Far right: This barn and outhouse stand on the very north end of Mormon Row. It is a testament to the hardy settlers of this area who homesteaded here in the 1890s.

Below: Homesteaded and built by rancher Pierce Cunningham in 1888, the Cunningham Cabin still stands today just south of Spread Creek. With an interesting past that includes suspected horse thieves, a gunfight, and serving as a fort, the Appalachian-style log cabin serves as a fascinating piece of Teton's homesteading history.

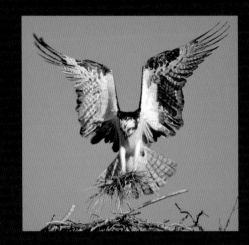

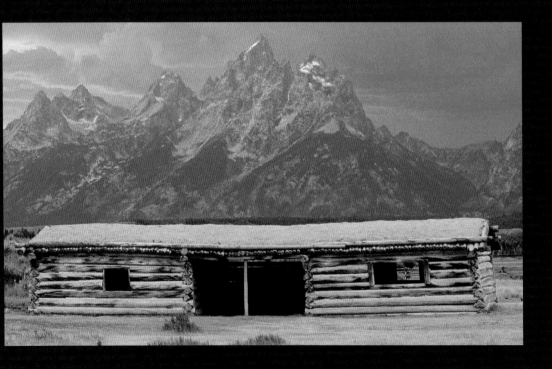

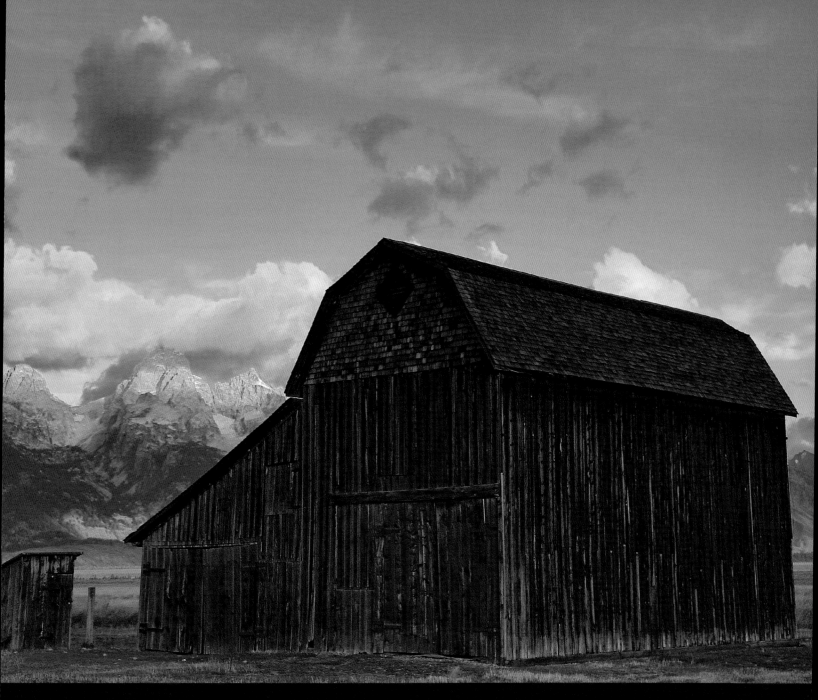

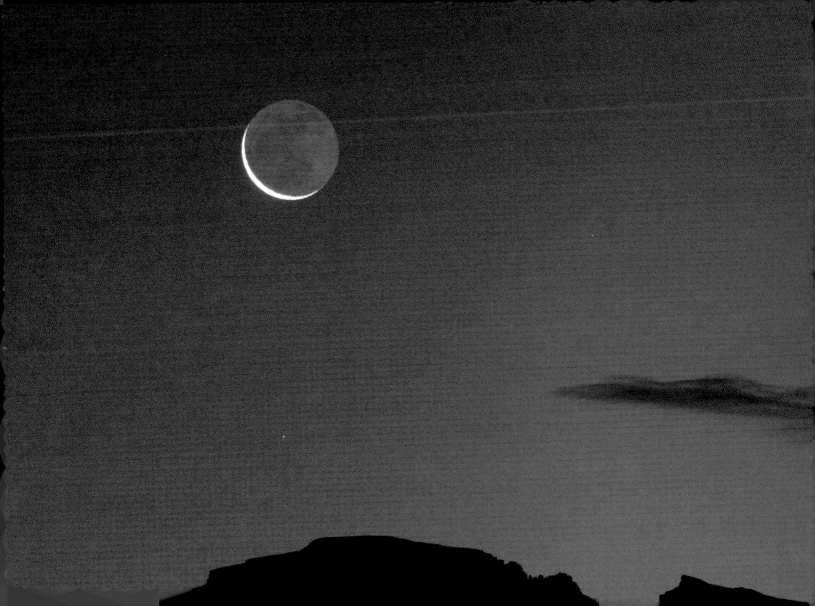

Left: A crescent moon rises just before dawn over the chest of the Sleeping Indian. Native Americans, who came to the Jackson Hole Valley to hunt game in summer for close to 11,000 years, knew it as "Sheep Mountain" due to the bighorn sheep that summered there. Although its official name is still Sheep Mountain, it is more commonly known as Sleeping Indian Mountain because it is thought to resemble a Native American with headdress sleeping on his back.

Below: Less than forty-eight hours old, this trumpeter swan cygnet hops a ride on its mother's back. He will grow up to be the largest of all waterfowl in North America, with a wingspan of nearly seven feet.

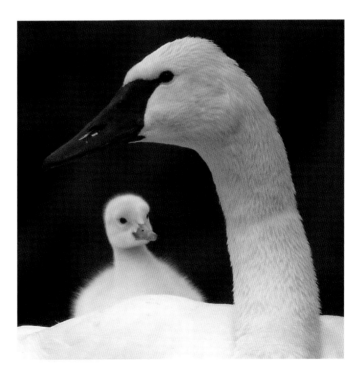

Right: A great gray owl hovers over its intended prey on a winter day. The owl uses its incredible sense of hearing to detect the movements of voles and pocket gophers under the snow before plunging through the upper layers to snatch it.

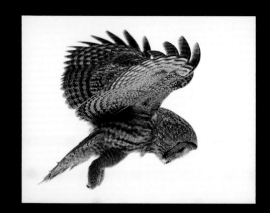

Far right: Bull moose feed and spar amid the sagebrush of Antelope Flats. This photograph was taken on December 21, the winter solstice and shortest day of the year in the northern hemisphere.

Below: The Luther Taylor Homestead, more commonly known as the "Shane Cabin," was used in the classic western movie *Shane* in 1953. It is one of the few remaining structures that represent Jackson Hole's rich movie making past.

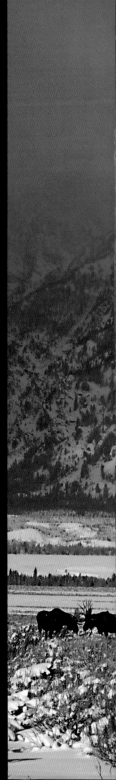

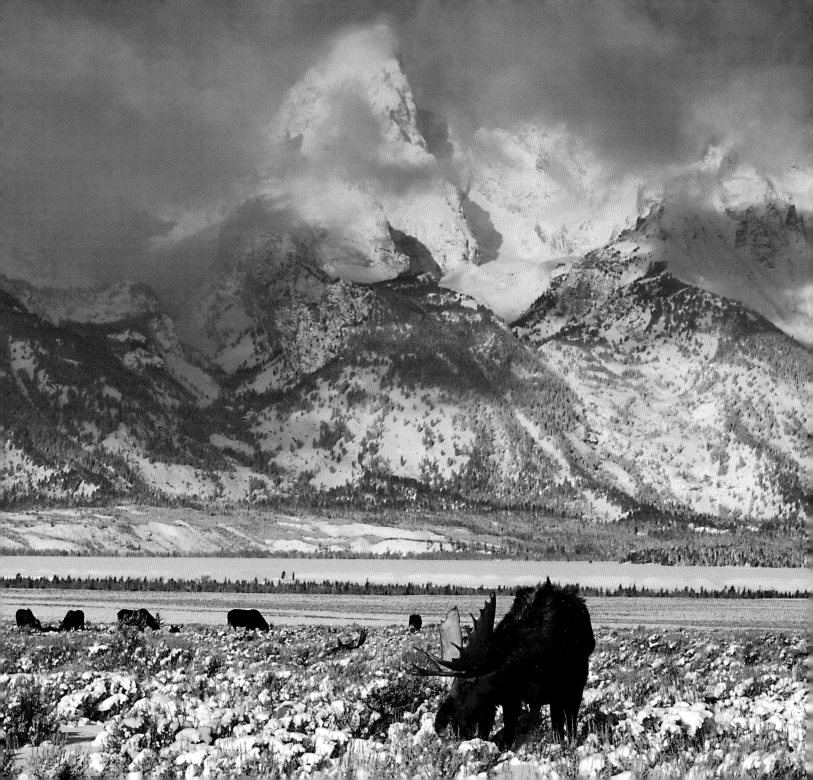

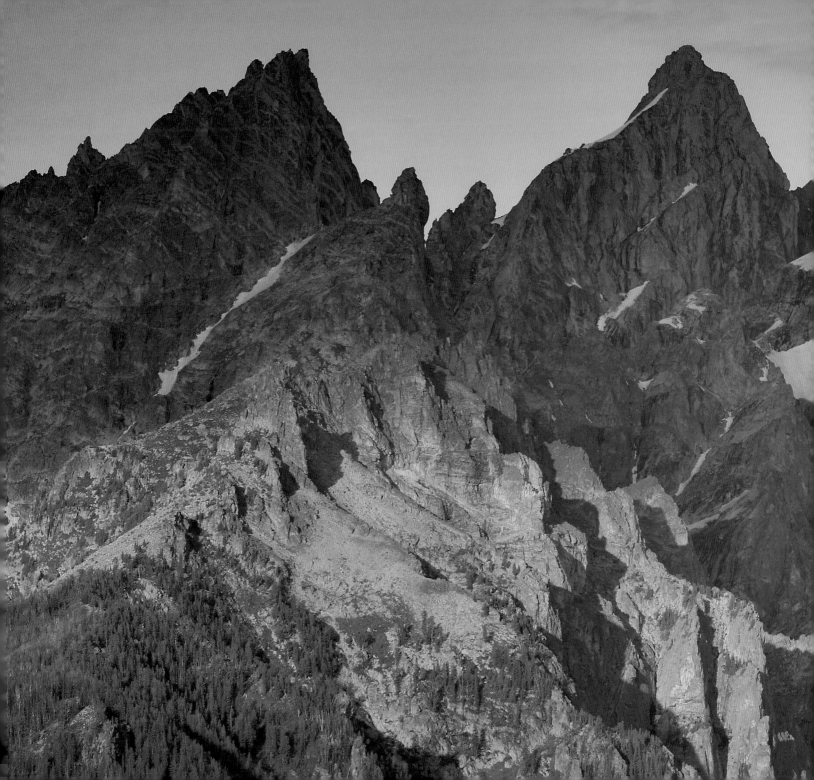

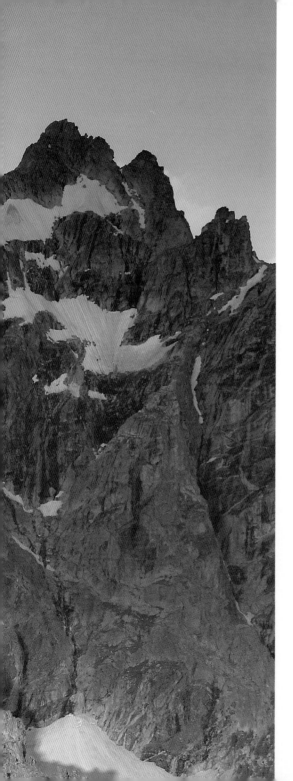

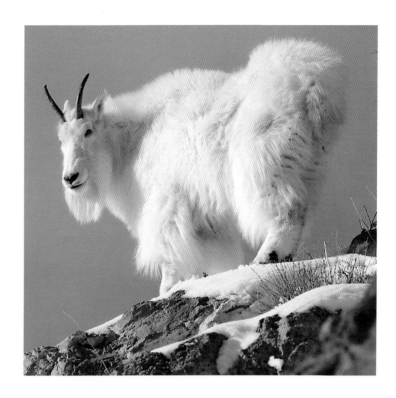

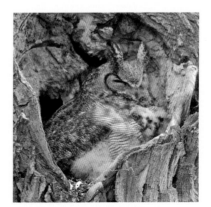

Above: A mountain goat crests a ridge in the Snake River Canyon south of Jackson.

Left: Two great horned owl chicks stay cozy underneath their mother inside the hollowed-out trunk of a cottonwood tree.

Far left: Morning light warms the peaks of the Cathedral Group, from left to right: Teewinot Mountain, the Grand Teton, and Mount Owen.

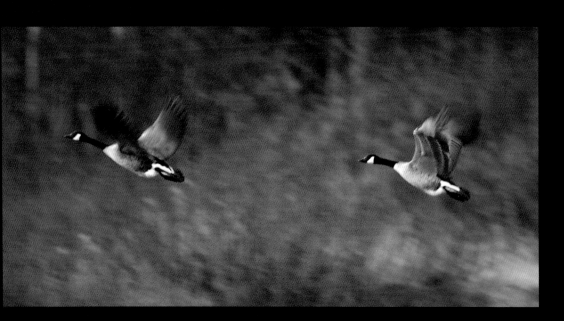

Above: Canada geese take to the wing at Oxbow Bend.

Right: By far the largest and most atypical buck I have ever seen in the Tetons struts his stuff during the mule deer rut in November.

Far right: Grizzly Bear 399 and her cubs wander through a meadow in Grand Teton National Park. Grizzlies most typically have two cubs and often a single cub at a time, with three cubs being far less common. Bear 399's fame from having three sets of triplets in a row is rarely seen. Several weeks after this photograph was taken, one of the two darker cubs became separated from its mother, most likely due to an encounter with another bear. This cub was subsequently adopted by its half sister, Bear 610, who was then four years old with two spring cubs of her own. She never seemed to miss a beat adding a third cub to her entourage and raising it for the next two years. Cub adoption among grizzlies is rare but has been previously documented on several occasions.

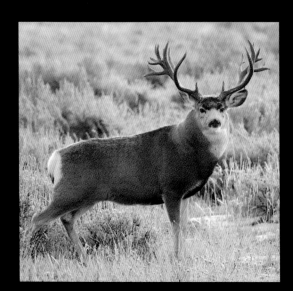

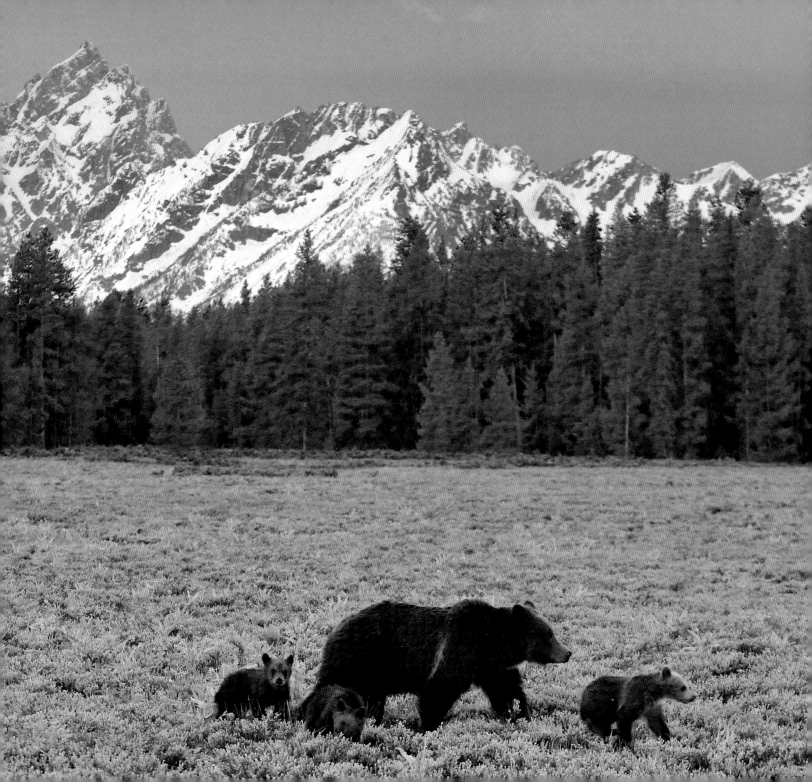

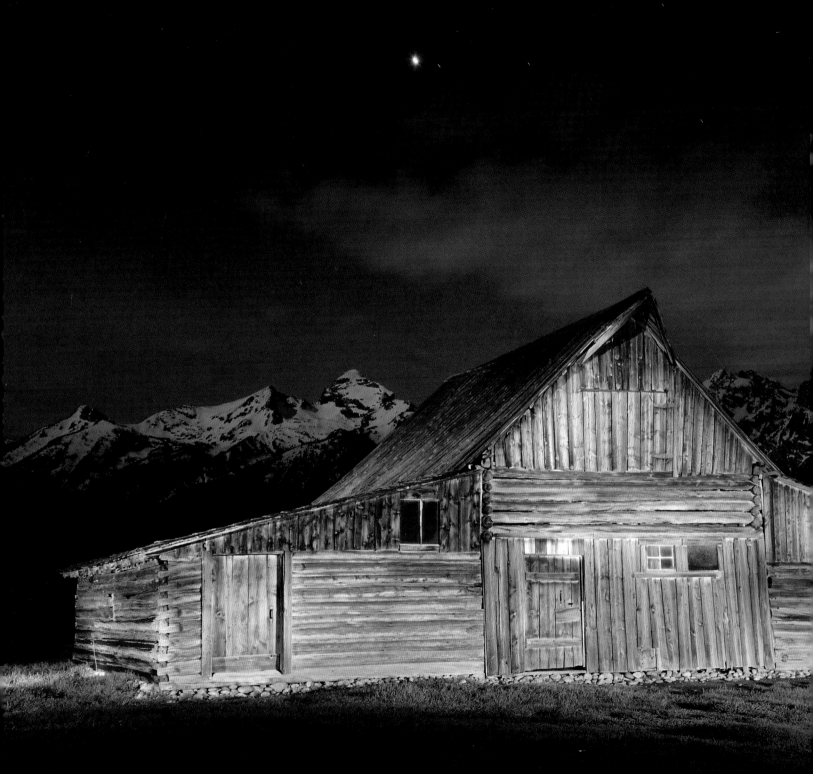

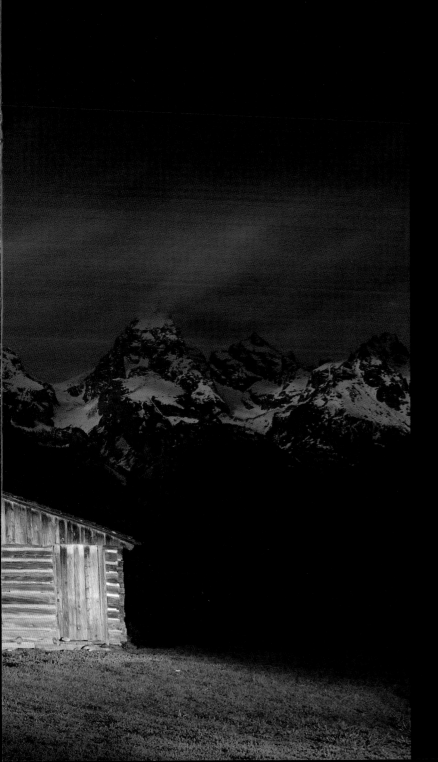

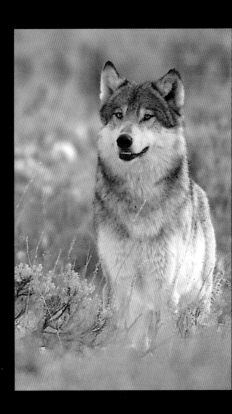

Above: A gray wolf pauses in the sage near Timbered Island in Grand Teton National Park. Wolves were reintroduced into Yellowstone in 1995 and found their way to Jackson Hole in the winter of 1999. The valley is currently home to six to eight packs of wolves. Though shy and rarely seen during daylight hours, these impressive predators play an important role in maintaining a healthy ecosystem. If you are fortunate enough to see a wolf or hear one howling, you know you are in a truly wild place.

Left: One of the most photographed barns in the world, the Moulton Barn has stood the test of time. Built in 1914 and reinforced on several occasions, the barn is over one hundred years old and an iconic fixture in Grand Teton National Park. Using a flashlight, I illuminated the barn at night using a technique known as light painting.

Next page: The Grand Teton makes a striking backdrop for a lone cow elk.

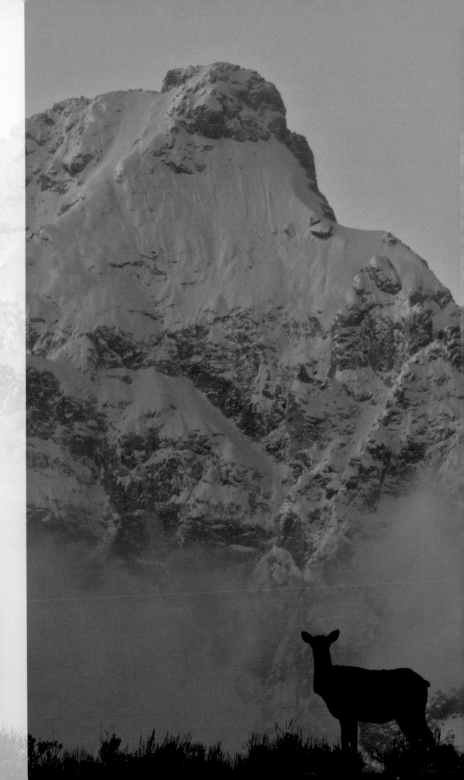

Henry H. Holdsworth has spent over thirty-five years photographing the wildlife and landscapes of Grand Teton National Park. Educated as a biologist, he has traveled to many remote and wild areas of the globe, but none is nearer to his heart than his own backyard in northwest Wyoming.

Henry's work has appeared in many leading magazines such as *National Geographic*, *National Wildlife*, and *Wildlife Conservation*. He has published seven previous books on the region with Farcountry Press.

Henry currently divides his time between photographing, teaching photography workshops, and running his Wild by Nature Gallery in Jackson Hole. When he is not off capturing new images, he can usually be found trying to keep up with his daughter Avery and their golden retriever Finn in his hometown of Wilson, Wyoming.